HOPPER'S PLACES

GAIL LEVIN
HOPPER'S PLACES

Second Edition

UNIVERSITY OF CALIFORNIA PRESS
Berkeley · Los Angeles · London

In honor of my mother, who taught me to love painting,
and in memory of my father, who taught me to love books

THE PUBLISHER GRATEFULLY ACKNOWLEDGES THE CONTRIBUTION PROVIDED BY
THE ART BOOK ENDOWMENT FUND OF THE ASSOCIATES
OF THE UNIVERSITY OF CALIFORNIA PRESS, WHICH IS SUPPORTED BY
A MAJOR GIFT FROM THE AHMANSON FOUNDATION.

University of California Press
Berkeley and Los Angeles, California

University of California Press, Ltd.
London, England

Library of Congress Cataloging-in-Publication Data
Levin, Gail, 1948–
Hopper's places / Gail Levin.—Expanded ed.
Rev. ed. of: 1st ed., 1985.
ISBN 0-520-21737-3 (hardcover : alk. paper)
ISBN 0-520-21676-8 (pbk. : alk. paper)
1. Hopper Edward, 1882–1967—Themes, motives. 2. United States—In art.
3. Paris (France)—In art. 4. Mexico—In art. I. Title.
ND237.H75L484 1998
759.13—dc21 98-16450
CIP

Printed in Canada

08 07 06 05 04 03 02 01 00
9 8 7 6 5 4 3 2

CONTENTS

PREFACE TO THE SECOND EDITION

Since 1985, when this book first appeared, I have continued my research on Edward Hopper. In 1995, I published two more studies, *Edward Hopper: An Intimate Biography* and *Edward Hopper: A Catalogue Raisonné*. Neither supplanted *Hopper's Places*, which introduced the way the artist worked. In the course of my research, I had found many of Hopper's subjects, proving that he often worked from actual sites. These I documented photographically and analyzed to show how he both recorded and transformed. My results have elicited enthusiasm from practicing artists and many others. Readers have welcomed the opportunity to share my discoveries, often going to see the sites for themselves.

Since the third printing sold out in 1995, I have frequently been asked when *Hopper's Places* would be available again. The University of California Press has not only made this possible, but has encouraged me to reach beyond the original focus on Hopper's New York and New England haunts. I have thus been able to include photographs taken as early as the late 1970s, including some sites that have since changed almost beyond recognition. This new edition adds the work of Hopper's formative years in Paris; his 1929 trip to Charleston, South Carolina, and Gettysburg, Pennsylvania; and his arduous journeys to the Western United States and to Mexico. Of course, those who want to see the entire range of Hopper's painting will turn to the catalogue raisonné, just as those who desire a more detailed account of his working method should turn to the biography, which often relates the gradual progress of a painting and which explores Hopper's sources in literature, the theater, and cinema.

Readers will notice that in selecting works to illustrate, I have favored architectural subjects over landscapes, just as Hopper did in choosing what he would paint. In the course of my research for the biography, it became ever clearer that Hopper's realist style may make his compositions seem simple and direct, yet they often suggest further levels of meaning. His pictures of architecture in particular often express more than meets the eye and call out for complex readings.

Hopper betrayed his metaphoric and self-reflective bent when he gave the title *Self-Portrait* to a water-

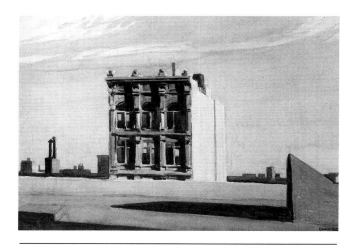

Fig. a. *Skyline near Washington Square*, 1925, watercolor on paper, 15¹/₁₆ × 21⁹/₁₆″.

color of 1925 that shows an isolated, narrow building that rises starkly above an austere rooftop and dominates the skyline, its windows staring and opaque in the raking sunlight. The title must have puzzled viewers who could not have known that Hopper often represented his own tall, thin frame in caricatures as exaggeratedly lanky and skinny, even skeletal. He had concealed the self-reference before he sold the work in 1927 under the title *Skyline near Washington Square*.

Another work of 1925 reveals a preoccupation that Hopper would return to in many paintings. In *House by the Railroad* (Fig. 6) he depicts an elaborate Victorian house of the sort that wealthy citizens were building in Hudson River towns when Hopper was growing up. But he shows the once proud dwelling cut off by intrusive rails. The memento of his small town boyhood has been relegated by technology to the wrong side of the tracks; and it is this clash between the familiar Victorian culture of his childhood and the dislocations of the twentieth century that attracts his attention and animates his work.

In the first edition of this book, I questioned whether a similar house in Haverstraw, New York, could have been Hopper's source for this painting. Since then, as I reported in the biography, I have learned that a like question occurred to John Maass, the author of *The Gingerbread Age* (1957). In the mid-1950s he wrote to Hopper inquiring which of two Haverstraw houses had served as his source. The artist's wife, the painter Josephine Nivison Hopper, responded as she often did for her taciturn spouse: "He did it out of his head. He has seen so many of them."

The dissonance between Victorian values and encroaching modernisms was recurrent and compelling for Hopper. He felt alienated by urban crowding, skyscrapers, airplanes, and other signs of change. When he painted the *Libby House* (1927, Pl. 14) in

Portland, Maine, not content merely to portray a picturesque old mansion, he emphasized a large rotting tree on the street corner, leaving us to meditate on the contrast between past glory and present decay.

The ever accumulating evidence of personal concerns in Hopper's work led me to reconsider an enigmatic canvas. *Shakespeare at Dusk* (1935, Pl. 3) depicts the statue of the Bard on the deserted Mall in Central Park against a backdrop of bare trees silhouetted in the sunset. Once my research showed that Hopper made the painting in the autumn after his mother's death, a comparison suggested itself with Shakespeare's famous visual picture in the seventy-third sonnet:

> That time of year thou mayst in me behold
> When yellow leaves, or none, or few, do hang
> Upon those boughs which shake against the cold,
> Bare ruin'd choirs, where late the sweet
> birds sang.
> In me thou see'st the twilight of such day
> As after sunset fadeth in the west,
> Which by and by black night doth take away,
> Death's second self, that seals up all in rest.

In Hopper's painting, as in the sonnet, it is winter, for the deciduous trees are bare. Reflecting on a death that marked a break with his own past, Hopper seizes on a contemplative time and place, which contains in the heart of the city, a monument to a

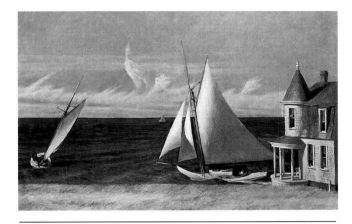

Fig. b. *The Lee Shore*, 1941, oil on canvas, 28¼ × 43″.

vanishing past. Beyond the trees the roseate sky is punctuated and invaded by the push of skyscrapers.

Not only Shakespeare, but Goethe, Emerson, and James were among Hopper's wide readings, documented by his wife's diaries, but also occasionally by him in interviews and in letters, and often providing themes for his work. A notable example is an oil painting, *The Lee Shore* (1941). In the course of research, I discovered that this was also the title of a concise and allegorical chapter in *Moby Dick*, which Hopper had read during the summer of 1938. Melville evokes the ship "that miserably drives along the leeward land" to suggest the soul that

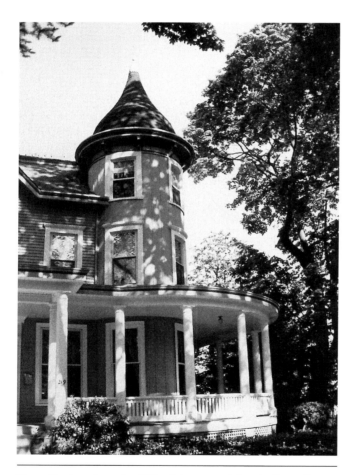

Fig. c. Porch and cupola of Nyack house next door to *Pretty Penny*.

must avoid her home harbor in order "to keep the open independence of her sea." Hopper's image of a ship driven by a strong wind close along a high shore could illustrate Melville's parable.

Underscoring Melville's theme of the "home harbor" that must be avoided to assure independence, Hopper places on the dangerous shore an ominous house with a conical cupola. Although he was painting in his studio on Cape Cod (Fig. d), the image recalls a house on his own street in his hometown. He had plenty of opportunity to associate the cupola with threats to his independence because it stands just a few blocks from the boyhood home where his spinster sister more and more required his attention. More specifically still, the cupola rises next door to "Pretty Penny," the home of Helen Hayes and Charles MacArthur, who commissioned Hopper to paint its portrait in 1939. He resisted but gave in to pressure from his dealer and his wife, in a period when other sales were slim. Working under protest, he made many visits to sketch and complained bitterly about his loss of autonomy, which smacked of the days when he had been forced to do illustrations for a living. Yet something of the illustrator resurfaces in *The Lee Shore*, which so closely synthesizes literature and life.

Research for the biography also revealed that in his later years Hopper relied upon observing specific

sites more often than anyone had previously realized. For *Approaching a City* (1946, Pl. 5), Jo noted in her diary that he was "going up town . . . & has found something to start on." Exploring, he had lighted on the unique locale at Ninety-seventh Street and Park Avenue, where the rail line to Grand Central Station passes from the viaduct over Harlem into the tunnel under Carnegie Hill. Some of the buildings have changed and graffiti now preempt the urban landscape, but the mystery of the place survives.

A mystery of passage again spurred Hopper in April 1949. Ill and facing imminent surgery, he began painting from memory the stairway and doorway of his boyhood home in Nyack (Fig. 7), which he still saw whenever he visited his sister. For this nostalgic work, he had recourse to wood panel, a kind of support that he had favored much earlier, particularly when he worked outdoors on Monhegan Island. Knowing these preferences, I thought the painting dated from the late 1910s. But then I found Jo's description of the work in her diary: "a little picture on a wood panel—a staircase going down to open door & hall lamp suspended. Said memory of a repeated dream of levitation, sailing downstairs & out thru door." (Pl. 6) Painting a remembered place with an imagined view "outdoors into moonlight," Hopper transformed reality, creating a picture which

corresponded to his distressed mental state of the moment, the morbid anxiety that the sun was setting on his life.

Depression exaggerated by his state of health may also underlie the painting that he produced two years later with the unrevealing title *Rooms by the Sea* (1951, Pl. 28). When he wrote to his dealer about the picture, an austere view out the door of his Truro studio (Fig. d) directly on to the water of the bay, he noted only: "I have finished a canvas am hoping to get another before we leave here." At the bottom of the letter, however, a note from Jo catches the uncanny nature of the image: "A queer one— could be called "the Jumping Off Place'—we can't count on that one ever being sold—even by a wizard like you. I mention this so you won't be counting on it too much." Jo's mention of "the Jumping Off Place," probably refers to an article by Edmund Wilson (which had first appeared in the December 23, 1931 issue of *The New Republic*) describing a seaside hotel on the West coast where "the suicide rate is twice that of the Middle-Atlantic coast."

Interrogated about his motives for selecting what he would paint, Hopper himself speculated: "I do not exactly know, unless it is that I believe them to be the best mediums for a synthesis of my inner experience." The delicacy and difficulty of finding subjects in which he could identify his inmost con-

cerns would go far towards accounting for his notorious painter's block. Many of his subjects seem rather ordinary. He did not find himself in scenes that by conventional standards were picturesque. By-and-large he preferred things that were familiar, but which his peculiar vision rendered strange. Yet too much familiarity could also make it impossible to paint. Two maps that Jo drew of Cape Cod (Fig. 11) make clear how often Hopper depicted sites conveniently located around him. He worked from Orleans to Provincetown, concentrating around South Truro, where beginning in 1930, he and Jo spent all but one summer and often stayed on through October. Ultimately, he had used up the local subjects that appealed to him, for as Jo noted in her diary after they returned from Wyoming in 1946: "He's done so many around here, about eaten up everything."

The search for suitable material could drive him restlessly to prowl New York and explore the outer arm of Cape Cod, or strike out across the continent and down to Mexico. Yet there were limits. An artist like Marsden Hartley (1877–1943) would hike through the woods for hours or climb a mountain in the winter to seek out some special view. Hopper came to prefer working from the comfort of his automobile. By the end of the thirties, he gave up painting canvases outdoors, preferring the studio of his Truro home with its large north window, glorious light, and view of the bay. He no longer wanted

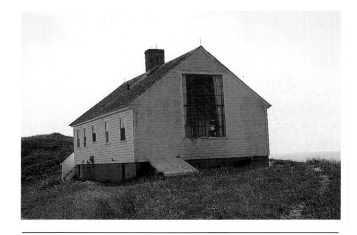

Fig. d. Hopper house, South Truro.

to endure mosquitoes, curious onlookers, wind, and other disturbances.

Nor did Hopper seek out sites because other artists had painted them, as Hartley did when he followed Cézanne to Mont Sainte-Victoire. In general, Hopper avoided sites others had previously depicted, preferring to choose more original material. It is not clear if Hopper knew that the once bucolic site of his painting of *Macomb's Dam Bridge* (1935, Pl. 4) had been recorded in a lithograph by F. F. Palmer. Even if he had known the print, he would probably not have realized that the artist was a woman. Fanny Palmer (c. 1812–1876) produced *Bass Fishing at Macomb's*

Fig. e. *Bass Fishing at Macomb's Dam, Harlem River, N.Y.,* 1852.

Dam, Harlem River, N.Y. in 1852 for Nathaniel Currier's popular printmaking firm, which merged with James Merritt Ives five years later. In general, Hopper disapproved of women artists, dismissing them as "lady flower painters." Palmer documented a pastoral New York, for which Hopper might have felt his customary nostalgia. He records the modern span designed by Alfred Pancoast Boller and built in 1895, which he captured on repeated sketching trips by subway up to 155th Street in Harlem and then painted in his Washington Square studio.

Number 3 Washington Square North, which forms part of the "Old Row" of handsome Greek revival houses built during the 1830s on the northeast side of the Square, was one of Hopper's most cherished

places. He moved there in December 1913 and it remained his home and studio until his death, May 15, 1967. By the time Hopper arrived in the neighborhood, cheap housing was attracting a new influx of Irish and Italian immigrants and others whose behavior rather than national origin classified them as Bohemians.

Hopper's choice of Greenwich Village did not lack irony. Bohemian life in Paris had never seduced him, although it captivated his eye and brush and pen. Nor did he demonstrate any taste for the convivial life or ever show any inclination for vanguards. About Gertrude Stein in Paris, he claimed to have heard only. Nor did he yearn for access to the famous salons of her friend, Mabel Dodge, who had returned from finding herself in Europe and set up a house of cultural innovation just up Fifth Avenue from Washington Square at the corner of Ninth Street.

At first Hopper occupied the back room on the top floor of the four-story walk-up, a climb of 74 steps. Only in the fall of 1932, did he and Jo (who had moved in after their marriage in 1924 and had given up her Ninth Street studio in 1925) shift to larger quarters in the front of the building overlooking the park. Until late 1938, when Jo took over an adjacent rear studio (at no extra rent since new city regulations prohibited renting it separately), they shared his studio, a small adjoining bedroom, and a tiny kitchenette.

Fig. f. Hopper studio, top floor, 3 Washington Square North.

Although quite run-down, the building was sought out by its inhabitants because of the park-side location, high ceilings, and the community of artists who lived and worked in its numerous studios. Hopper's had neither central heating nor a private bathroom, but the light from the large skylight was exceptional. Thus, the building could point to a distinguished roster of former tenants including artists Thomas Eakins (whom Hopper especially admired), Abbot Thayer, Thomas W. Dewing, Will H. Low, Augustus Saint-Gaudens, Walter Shirlaw, and William Glackens.

Today the building (which now can only be entered around the corner on University Place) houses the School of Social Work of New York University. Once the university took over the property in 1946, the Hoppers fought eviction. They became the building's last remaining tenants, sharing their beloved home with university offices. The space of the Hoppers' last quarters (with its skylights, tilting plank floors, wood-burning stove, and tiny, archaic kitchen) has survived the building's massive remodeling, reputedly due to a dean who admired Hopper's work. Yet despite plaques and commemorative photographs, Hopper's studio now serves only as office space.

Let me close with a word about the role of photographs in my study. It was and is not my intention to investigate the influence of photography on Hopper (which I discuss briefly here, but also in both

the biography and the catalogue raisonné). Nor do I deal with the influence of Hopper's work on photographers—his contemporaries or ours. Hopper's art has long been compared to the photographs of Walker Evans, with whom he shared certain sensibilities. Since the first edition of this book was published, such coincidences of subject matter and aesthetics between Hopper's art and diverse photographers have been the subject of a large museum exhibition held in Essen, Germany.

No photograph can reproduce precisely the subject as it meets a painter's eye. In Hopper's case, time has intervened, sometimes more than eighty years, between his paintings and my photographs, which I began taking in 1976 and completed in 1998. Photographs record only an instant in time seen from a single point of view. Hopper's paintings, on the other hand, reveal the result of a sustained study over time. The artist/observer looks at the site and frames the composition gradually as he works, looking again and again at the view in the process. Light and shadows change with the sun's movement. Clouds may further affect the perception of the scene. In painting or drawing on location, the artist's eyes shift, taking in different angles of vision and creating different perspectives, even though no conscious attempt to change position has occurred. Thus, Hopper's pictures synthesize myriad observa-

tions in a way that eludes the single photograph. Today, with digitized images, one might attempt to simulate Hopper's vision by using a computer to combine photographs taken over time. My intention and procedure have been more documentary.

Hopper expressed disappointment that the camera sees things from a different angle than the eye, pointing up some of the unintentional distortions that occur when recording through a camera lens. In my discussion of Hopper's composition, I relate his choice of unusual angles of vision, often elevated or below the level of his subject, to his admiration for Degas's work. In trying to duplicate these vantage points at the actual sites, I sometimes had to tilt my 35mm camera, resulting in a slight exaggeration. For example, in my photograph of *Talbot's House* (Pl. 8), the chimney appears to be at a greater angle than Hopper painted it because I had to take the photograph looking up, while a photograph taken at eye level would avoid such a slant.

The effort to take these photographs forced me to look more closely at Hopper's paintings and to analyze them in new ways. It is my hope that my work in this new edition will continue to allow others to enhance their own understanding of Hopper's creative process.

Gail Levin
New York City, May 14, 1998

HOPPER'S PLACES

I began photographing places Hopper painted quite by chance. During the late 1960s, I spent a Thanksgiving vacation with a college classmate in Portland, Maine. Showing me around her hometown, she drove me out to Cape Elizabeth to see the lighthouse at Two Lights, which had been painted, she proudly informed me, by the artist Edward Hopper. I had been greatly impressed by Hopper's work, examples of which I had seen in the Museum of Fine Arts in Boston, and decided at once to take a picture of his motif. I also photographed my friend standing before the lighthouse. At the time I was both an art and an art history major and had been painting my own Cape Cod landscapes in a realist style inspired by Hopper.

I routinely tucked these snapshots away in an album, never dreaming that I would later spend eight years as curator of this artist's estate at the Whitney Museum of American Art, where I organized major Hopper exhibitions and wrote a catalogue raisonné, a definitive study of the artist's work, as well as articles, books, and catalogue essays. I approached my work there with great enthusiasm and thoroughness. So much so, that a male journalist who interviewed me in 1980 in Milwaukee, on the occasion of the opening of a Hopper exhibition that I had curated, incorrectly concluded: "The man in Gail Levin's life has been dead for thirteen years" (Hopper had died in 1967, just before his eighty-fifth birthday). Perhaps this journalist would have been even more perplexed had he known of my travels tracing Hopper's footsteps, searching out the very sights he had painted.

This idea began not only in my chance encounter with the lighthouse on Cape Elizabeth but also in an experience I had had during the previous year while I was studying in Paris. On spring vacation, I had taken an overnight train south to Aix-en-Provence to meet a friend. This was my first visit to the south of France, and although I was quite familiar with the great painting that had been produced there, I did not expect the actual landscape to resemble so closely these icons of modern art. Rather I imagined that artists such as van Gogh and Cézanne had created their images more from their imaginations and sources in other art such as Japanese prints. Awakened in the early morning just at sunrise, I stood looking out the train window in amazement at the landscape of Provence with its cypresses and orchards with gnarled tree-trunks so evocative of van Gogh. My stay in Aix, where I visited Cézanne's studio and saw some of the places that he had painted, reinforced this impression. How these artists had responded to the world around them and captured it in their canvases!

I soon discovered the 1943 book *Cézanne's Composition,* by the painter Erle Loran, as well as his original article "Cézanne's Country," published in the April 1930 issue of *The Arts,* where the first photographs of

the artist's motifs appeared. Later I delved into the pioneering work on Cézanne by the art historian John Rewald, who published his photographs of Cézanne's sites in a number of articles, including a marvelous essay, "The Last Motifs at Aix," which appeared in the catalogue of the 1977 exhibition at the Museum of Modern Art, *Cézanne: The Late Work*. This last article reinforced the value of such precise documentation in the context of my own research on Hopper.

Rewald described how he and his friend, the painter Leo Marchutz, had, against the property owner's wishes, surreptitiously cut off tree branches in order to "'liberate' views of the buildings which they obstructed." He also lamented how rapidly things changed, eradicating Cézanne's views forever: "Forest fires ruined some sites, new construction others." This, in fact, predicted my own experience with Hopper's places. Sometimes, the extensive growth of landscaping trees and bushes conceals the structures Hopper painted, rendering them all but unrecognizable; elsewhere, the sprawling growth of suburbia has crept up on the most tranquil of locales. I have witnessed these dramatic changes even in the relatively short time I have been visiting and documenting Hopper's places, particularly at the lighthouse at Two Lights on Cape Elizabeth (which I have visited intermittently now for over sixteen years), where new construction now blocks some of the vistas that once delighted him.

Perhaps in America, where Hopper painted, change is even more rapid and drastic than that observed by Rewald in the south of France. Here we tend to praise such uncontrolled growth and call it progress. In this sense, both painters and photographers of cityscapes and landscapes serve the function of creating a permanent record of the appearance of places that are subject to constant transformation.

And to understand a realist painter like Hopper, we must explore both his choice of subject matter and his method of depiction. Just how faithful to his observations was he? One accurate way to assess this aspect of his work is to compare his actual subjects, where they survive, to their appearances in the paintings themselves. Born in 1882, Hopper began in his boyhood to sketch and paint motifs in his environment; by the 1910s, he had returned from his travels abroad and had seriously begun to record the world around him. Thus, it was none too soon that I began to photograph Hopper's sites, some of which no longer existed and some of which have changed beyond recognition since I photographed them. In most cases, by the time I arrived at these places, camera in hand, decades had passed since Hopper had painted there; but fortunately he was attracted to backwater locations where the force of progress has been gentler than might be expected.

In this volume, I have decided to focus on Hopper's most important American places—New York City and

its environs; Maine; Gloucester, Massachusetts; and Cape Cod—for it is in these locations, in the places he knew best, that his work is most revealing. I have treated his response to Paris and Mexico in articles in *Arts Magazine* (June 1979) and *Geo* (February 1983). Other places to which he traveled—Santa Fe, New Mexico; Charleston, South Carolina; and parts of Wyoming, Oregon, and California—could also have been included. Rather than pass by too quickly, however, I have chosen to investigate the most significant locales more thoroughly, attempting to illuminate the artist's motivations and working procedure.

HOPPER'S SUBJECTS

Edward Hopper (1882–1967), the quintessential realist painter of twentieth-century America, portrayed the commonplace and made the ordinary poetic. In choosing his subjects, from rural New England (Maine, Vermont, Cape Ann, and Cape Cod) to South Carolina, New Mexico, and New York City and its environs, Hopper was drawn to stark architectural vistas which he usually emptied of human figures—spare compositions and situations evoking feelings of loneliness and solitude.

Hopper's realism was not merely a literal or mimetic rendering of what he saw but an interpretive rendering of the settings he depicted. His choice of subjects is well worth examining, for therein lies an important clue to the very nature of Hopper's vision. The places that Hopper painted reveal much about his personality, his tastes, and the cultural climate of his time.

One of the most frequently recurring images in Hopper's oeuvre is a view of a body of water: seascapes and nautical scenes, lighthouses, harbors, rivers, bridges, and even the view from his summer home in Truro, Massachusetts, overlooking Cape Cod Bay. Having grown up quite near the Hudson River in Nyack, New York, Hopper was always drawn to water, which may have symbolized freedom and escape for this reclusive artist. As an adolescent, he had been encouraged by his father to build a sailboat, evidently so that he would get outside and be less of an introvert. Later Hopper admitted that he had considered a career as a naval architect; sailing remained a lifelong passion. The many lighthouses he painted may reflect a certain identification on his part: he was nearly six feet five inches tall and perhaps felt a special affinity to this genre of architecture, which, like him, stood apart, detached from the rest of the world.

While Hopper's architectural subjects are generally devoid of human figures, it was not until 1933 that his imagery was specifically described as "lonely." This subsequently prompted critics to make retrospective assessments of the art he had produced in the previous

two decades. Hopper himself, asked to explain the absence of figures in *Macomb's Dam Bridge* (1935), a painting that depicts New York, a city of millions of people, offered: "I don't know why except that they say I am lonely."

Hopper's empty places and solitary figures repeatedly suggested pangs of loneliness to a public increasingly interested in psychoanalytic thought and aware of the growing anonymity of contemporary urban life. By 1964, these interpretations of his work forced Hopper to insist that "the loneliness thing is overdone," although that same year he responded to an interviewer's assessment of "profound loneliness" and a lack of communication in his art with the comment: "It's probably a reflection of my own, if I may say, loneliness. I don't know. It could be the whole human condition." As early as 1923, Hopper titled an etching *The Lonely House*; but since the composition includes two children, the title suggests a larger, more existential loneliness —a kind of societal isolation. This is similar to the sense of estrangement present in his oil painting *House by the Railroad* (1925, Fig. 6) or in his various paintings of isolated lighthouses.

Perhaps Hopper's alienation results from his reclusive personality, which, as noted earlier, was already established in childhood. He felt a frustration in human relationships that he communicated in his art, not only through melancholy solitary figures but also

through metaphors for escape (trains, highways) and through the depiction of so many empty places, often where we would expect people to be present. In this sense, we must recognize that a painting like *Solitude* (1944) reflects Hopper's preference for empty spaces over the company of others, which he found difficult to accept.

Hopper's associations with the particular architecture he chose to paint are more complex. The early twentieth century was an era of burgeoning nationalism, and typical American scenes do appear as the subjects of his art. His hometown, Nyack, offered examples of architectural styles characteristic of nineteenth-century America. Although these styles were passively absorbed by Hopper in his youth, it was not until after he traveled abroad, between 1906 and 1910, that he fully came to appreciate their charm. Writing in *The Arts* in 1927, Hopper commented on contemporary American artists whose work he admired and stressed the necessity of developing a "native art," reiterating a point many critics were then noting about his own work: "The 'tang of the soil' is becoming evident more and more in their painting....We should not be quite certain of the crystallization of the art of America into something native and distinct, were it not that our drama, our literature and our architecture show very evident signs of doing just that thing."

For example, Hopper was especially fond of the kind

of roof so frequently found on American houses of the Second Empire style, built between 1860 and 1890. This style, which like its name is borrowed from French architecture developed during the reign of Napoleon III, is characterized by a mansard roof covered with multicolored slates or tinplates. In 1907 and 1909, Hopper had made several paintings of the Pavillon de Flore of the Louvre, which he could see from the corner where he lived on Paris's Left Bank. He undoubtedly admired the mansard roof of this elegant building and later must have been attracted to similar roof structures on American houses, which he depicted in watercolors such as *The Mansard Roof* (1923, Pl. 15), *Haskell's House* (1924, Fig. 2), and *Talbot's House* (1926, Pl. 8), as well as in his oils *House by the Railroad* (Fig. 6) and *The Bootleggers,* both of 1925. Since Hopper found these houses in a variety of locations—Gloucester, Massachusetts; Rockland, Maine; and probably New York state—it appears that he actually sought each of them out because of his fascination with the intricate mansard roof, flanked by classical moldings and ornamental details such as cornices and arched windows.

Although it seems at first glance that Hopper was routinely drawn to the most ordinary of buildings, there is inevitably something special about the subjects he selected—often a personal preference or specific

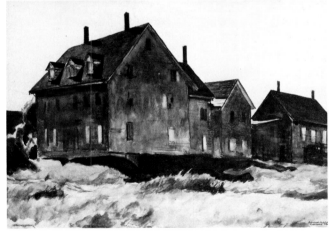

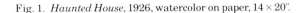

Fig. 1. *Haunted House*, 1926, watercolor on paper, 14 × 20".

association. For instance, in 1926, visiting Rockland, Maine, he had stumbled upon a deserted boarding-house at 5 South Street, near the town's shipyard. Old photographs document Hopper's verisimilitude to this subject, now long since destroyed. Despite its ordinary structure, Hopper was drawn to its state of abandonment, noting particularly its boarded-up windows and even titling his watercolor *Haunted House* (Fig. 1)—although the work has subsequently been known as *Old Boarding House*, masking the substance of the artist's original preoccupation with what must reflect his growing fascination with death. This morbidity and his characteristic pessimism are also indicated by Hopper's predilection for painting watercolors of houses surrounded by dead trees: *Dead Trees* (1923), *Dead Tree and Side of Lombard House* (1931), *House with Dead Tree* (1932) and *Four Dead Trees* (1942).

Hopper occasionally selected architectural subjects of greater aesthetic distinction. This was particularly true in 1927, during his stay in Portland, Maine, where he chose to paint watercolors of a distinguished high Victorian mansion and the elegant granite United States Custom House built in 1872 in a Grecian style. These choices were in sharp contrast to some of the more commonplace buildings that he had painted, just one year earlier, in Rockland, Maine.

His choices of subject matter—particularly the places he painted—seem to have been somewhat un-predictable, since they were part of his constant battle with the chronic boredom that often stifled his urge to paint. This is what kept Hopper on the move—his search for inspiration, least painfully found in the stimulation of new surroundings. As he explained to one critic: "To me the most important thing is the sense of going on. You know how beautiful things are when you're traveling."

HOPPER'S METHOD

As a young man just out of art school, Hopper first traveled to Paris in the fall of 1906 and remained there until the following summer. He then visited London and ventured across Europe, stopping off in Haarlem, Amsterdam, Berlin, and Brussels. After a second trip to Paris in the spring and summer of 1909, he toured Spain during June 1910 before passing the last weeks he would ever spend in Paris. Back home in America, as a struggling young artist reluctantly working as an illustrator, Hopper (according to what little is known of his life at this time) still managed to spend most of his summers in the country, away from the steaming streets of New York. He went to Gloucester, Massachusetts, in 1912; to Ogunquit, Maine, in 1914 and 1915; and to Monhegan Island, twelve miles off the coast of Maine, every summer from 1916 to 1919.

It was a return to Gloucester during the summer of 1923 that changed Hopper's direction. There he ran into Josephine Nivison, who, like him, had studied with Robert Henri at the New York School of Art. Nivison had already exhibited her watercolors in New York, and she encouraged Hopper, who had used the medium only as a boy and, more recently, for his commercial work, to try working in watercolor that summer on painting excursions they made together. She also recognized his unusual facility and respected his ability. When she received an invitation to show her watercolors in a group show at the Brooklyn Museum that fall, she told the museum about Hopper's new work in the medium, prompting his inclusion in the exhibition. This exhibition resulted in the museum's purchase of *The Mansard Roof,* Hopper's first sale of a painting in a decade, and brought him much favorable publicity. Perhaps Hopper, then aged forty-one, realized that he had at last found his best ally; he married Jo the next summer, and they spent their honeymoon back in Gloucester, painting watercolors.

Hopper painted his watercolors directly while looking at his subjects, which were almost always outdoor scenes: ships, the seashore, a lighthouse, a church, streets, houses, and trees. Having worked in watercolor as an illustrator, he handled the medium with confidence. After outlining his composition with a pale pencil sketch, he improvised as the work progressed, focusing on the recording of sunlight, interested in structure rather than texture. The result of Hopper's improvisatory technique is a spontaneity that does not occur in his oil paintings, a contrast that is especially notable when one compares the occasional oils that Hopper painted based on earlier watercolor compositions.

Before 1927, when Jo and Edward purchased their first automobile, Hopper's daily watercolor expeditions were usually on foot, and he was subject to wind and rain and other inconveniences. Their first car—they always bought them second-hand—provided not only transportation but also a mobile studio. With the front seat pushed forward to accommodate his long legs, Edward worked in the backseat behind the steering wheel, while petite Jo, nestled next to the driver's seat, produced her own watercolors or sketches. Despite his thrifty nature, Hopper always insisted on replacing any windshield of tinted glass so that he could see his surroundings in their proper tonality.

In Paris, Hopper had painted all his oils outdoors on location. Of course, during the cold rainy months of winter, this limited his production. He found other diversions for this time, however, and he frequently sketched in cafés, endlessly observing the French who provoked his fantasies. Back in America, Hopper had already begun to improvise, painting on occasion in the studio from memory or his imagination. He continued

to work outdoors during the summers that he spent in rural New England, evidently often sketching and painting directly on the canvas without making separate preliminary sketches.

Increasingly, though, Hopper began to make pencil or charcoal drawings on location, sometimes recording notes about color observations. These drawings were always done in monochrome, usually black and white but occasionally red Conté crayon. By the late 1930s, all of his canvases were produced in the studio; many were syntheses of several places Hopper had observed and sketched. For example, *New York Movie* (1939) combines drawings made at several theaters with sketches of Jo posing as the usherette in the hallway of their apartment building. Hopper never gave up working from observation; but as old age and infirmity made traveling about more difficult, he adapted by transforming his surroundings through the filter of his imagination.

HOPPER'S COMPOSITION

Photographs of the sites Hopper painted demonstrate how closely he followed nature. Nonetheless, they also reveal how on occasion he freely altered what he observed. He could subtly change the spatial organization of a composition from that which he could objec-

tively see to one that better suited his purpose. It is important to consider when and just how much Hopper chose to manipulate nature, how he selected his eye level or horizon line and his point of view, what decisions he made about the cropping of images, and how much he distorted scale and shape to suit his expressive needs.

Although Hopper did not work from photographs (except occasionally in his early commercial illustrations), he did admit to having once purchased a camera in order to take pictures of architectural details. The results of the camera disappointed him because, he recalled, "the camera sees things from a different angle, not like the eye." He explained to fellow painter Raphael Soyer that images in photographs "do not have enough weight." Hopper did, however, admire "how much personality a good photographer can get into a picture," and he specifically singled out the work of the French photographer Eugène Atget, whose work he probably first discovered in Paris. Atget's solitary, empty spaces and melancholy mood must have appealed to Hopper as they echoed his own vision.

In *Davis House* (1926, Pl. 18), Hopper compresses the foreground in size, omitting the intervention of the street that lies between the house and the fence bordering the churchyard where he was working. By cropping the house abruptly on the left side rather than including the entire structure, he suggests that the scene con-

tinues beyond the confines of his composition, adding an extra degree of realism to his verisimilitude.

By cropping the house in *Rooms for Tourists* (1945, Pl. 27) at the top of the composition, Hopper ensures that the viewer's eye does not wander up the triangular gable and out of the painting. Instead, he forces our attention back down into the center of the composition. He had also employed this device of cropping the top of an image in earlier works such as *Anderson's House* (Pl. 17), *Libby House* (Pl. 14), *Captain Strout's House* (Pl. 12), and *House on Middle Street* (Pl. 19).

More complicated was Hopper's use of multiple points of view, allowing the spectator to see his subject as it actually looked from several different positions. This seems to add to the sensation of realism, because it creates a sense of omniscience in the viewer, who can grasp more than could an actual spectator standing in a fixed location. For example, in *Rooms for Tourists*, which was constructed in the studio from drawings done on location, we see the side of the boardinghouse and the two houses on the adjoining right lot from the left, while the facade appears much more frontal. By appearing nearly parallel to the picture plane, the bordering hedge serves to emphasize this sense of frontality.

In *Davis House* Hopper's station point—his distance and position in relation to his subject—is also ambiguous. While the central house appears quite frontal, as if

he stood directly across from it, Hopper also utilized another vantage point, off to the left side, so that we look onto the side of the house next door. This is clarified when we examine the shadows in the watercolor. The gables on the roof of the central house cast shadows to the left of the composition, indicating that the sunlight is coming from the right side. At the same time, the concrete post on the fence is viewed from the left and inconsistently highlighted by a second light source coming from the left. The angle of vision is very low, perhaps because the artist was sitting on the ground, so that the viewer looks up under the eaves of the house.

Hopper often utilized an unusual angle of vision, either from an elevated position or from below his subject. The latter, often referred to as a worm's-eye view, includes works such as *The Mansard Roof, Haskell's House, Lighthouse at Two Lights, House on Dune Edge* (Fig. 3), or *Near the Back Shore* (Pl. 24). Here one senses the influence of Degas, whose work Hopper openly admired. Degas even wrote: "Equip the studio with benches arranged in tiers to inculcate the habit of drawing objects seen from above and from below." Although all of Hopper's positions were logically chosen according to the natural inclines of the surrounding landscape, he selected these vantage points intentionally, fully aware of Degas's proclivity for such compositions. The same is true of works painted from an elevated position or bird's-eye perspective: *Portland*

Head-Light (Pl. 11), *Dauphinée House* (Fig. 13), *November, Washington Square,* or *City Roofs* (Pl. 1).

Many of Hopper's subjects are viewed from an oblique angle off to the left side: *House by the Railroad; Anderson's House; House on Middle Street; Adam's House* (Pl. 21); *Prospect Street, Gloucester* (Pl. 20); *Rich's House* (Pl. 22)—to name only a few. Less frequently, he reversed this kind of composition and employed a view from the right-hand side: *Talbot's House, The Mansard Roof,* or *Haunted House.*

Hopper's inclusion of the rail-and-post fence in *Davis House* is not based on formal considerations alone. He used this fence as a psychological barrier, setting up a firm distancing device between himself and his subject. Characteristically, he did not allow himself (or the viewer) to become too involved or too threateningly intimate with the subjects in his paintings. This use of a fence as a barrier abounds in paintings such as *Haskell's House; Parkhurst House (Captain's House); Captain Strout's House* (Pl. 12); *Libby House; Custom House, Portland* (Pl. 13); *Rich's House;* and *Two Puritans.* In *Captain Strout's House,* although the original fence probably paralleled the house just as the present one does, Hopper placed it at an oblique angle in order to add a dynamic quality to the composition. Other barrier devices that he frequently used for both compositional and psychological purposes are railroad tracks and embankments, highways and roads, steep elevations in the landscape, and doorways and thresholds.

Hopper also took liberties in changing the relative proportions and even the shapes of his subjects. He most often made buildings appear to be more vertical than they are in reality. This tendency to elongate structures may have been the result of his subconscious identification with his own great height. Examples of this phenomenon can be seen in *Lighthouse Hill* (Pl. 9), *Captain Upton's House,* and *House on Middle Street,* where the actual houses are clearly broader than he chose to depict them. Sometimes Hopper flattened out forms as well. In *The Mansard Roof,* for example, we cannot really detect the angle where the two windows meet on the side of the house on the far right. Instead, Hopper, who in this early watercolor seems to have been preoccupied with the dramatic play of light and shadow, was willing to utilize compositional manipulations to achieve the look he wanted. In this he continued, developing subtle skills and effective devices.

FINDING HOPPER'S PLACES

My search for Hopper's places took many forms, from the most directed investigation to the serendipitous. I began by examining Hopper's paintings of easily identifiable places: *The Lighthouse at Two Lights;*

Macomb's Dam Bridge; Prospect Street, Gloucester; and *Custom House, Portland.* These places proved simple to locate and appeared relatively unchanged. In the process, I became familiar with Hopper's territory and began to understand what kind of places attracted him. I could say with confidence that Hopper might have painted this or would never have painted that.

As I collected photographs of all his known works for the catalogue raisonné, I discovered unpublished or little-known images which I then recognized while visiting the areas in which he painted. I found that he did tend to paint additional works while in the vicinity of another one of his subjects. I learned to think of Hopper's working method, whether he was on foot or in his automobile, and was able to find not only the locations he painted but the places where he worked. These discoveries in turn have led me to a greater understanding of how he selected the places he painted.

Familiarity with the record books kept by Jo, in which Hopper often made miniature sketches of his works, offered some further clues, although Hopper was usually vague about where in a given town a work was painted. In Gloucester, I had no trouble finding the subject of *House on Middle Street,* but the unidentified locations of so many other houses painted there presented greater challenges. Initially, just driving and walking around, I found a few of his sites. It helped to have a friend along to take the wheel, so that I could

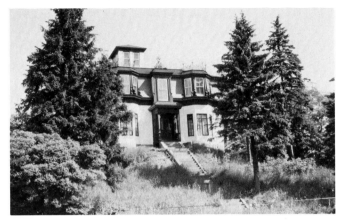

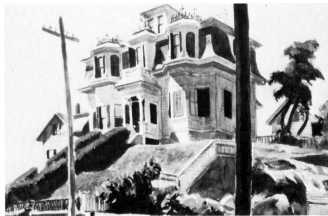

Fig. 2. *Haskell's House,* 1924, watercolor on paper, 14 × 20″.

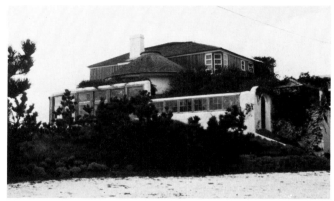

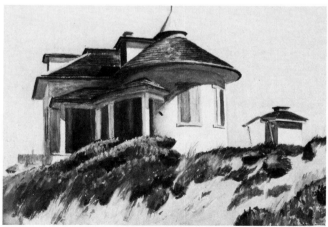

Fig. 3. *House on Dune Edge*, 1930, watercolor on paper, 14 × 20″.

keep my eyes on the houses. I recognized the model for *Anderson's House* while cruising by on the way to some other place. Stopping to take a photograph, I spoke to a man applying a coat of paint to the house's exterior: "Did you know that Edward Hopper once painted this house?" "All I know is that I'm painting it now," he replied—demolishing my fantasy that I had discovered a struggling artist working as a house painter on the very structure that Hopper had depicted.

Having found as much as I could on my own, I decided to visit a fire station because I figured the firemen would be likely to recognize existing buildings. When I showed photographs of Hopper's Gloucester paintings to a group of firemen, they looked at them with interest and offered various tentative suggestions until I came to *Adam's House*. One man perked up and offered: "I know that one—my mother lives in that house!" Of course I received a lot of false leads from well-meaning people at the firehouse and elsewhere: Hopper's paintings have a quintessential look about them and seem familiar even when they are not.

One of the problems was recognizing places that have been camouflaged since Hopper painted them. I had driven by the subject of *Haskell's House* (Fig. 2) many times before I recognized it. Although the house is distinctive, its shrubbery is missing, and large fir trees disguise the setting, now so radically changed by the transformation of Gloucester harbor. In North

Truro on Cape Cod, the model for *House on Dune Edge* has been so enlarged that the original distinctive round structure is now enclosed by the additions, totally changing the spirit of the place Hopper painted in 1931 (Fig. 3).

Another dilemma I faced was wasting time searching for places that might no longer exist. The abandoned Rockland boardinghouse of *Haunted House* (1926), the North Truro warehouse in *Cold Storage Plant* (1933, Fig. 5), and the South Truro train station in *Towards Boston* (1936, Fig. 4) had all been torn down, but there are old photographs that document Hopper's verisimilitude to these places. I found the photograph of the station on exhibit when I made a chance visit to the Museum of the Truro Historical Society.

Yet so many places Hopper painted have survived intact. I found old houses still standing in all the locales where he worked. In Paris, the building he lived in is unchanged, including the stairwell and inner courtyard, which he painted. In Saltillo, Mexico, I not only found the views Hopper recorded but visited the Hotel Arizpe Sainz, where he stayed. There I found that he had chosen a room with direct access to the roof, where he painted in an environment recalling his work on the top of 3 Washington Square North in New York. The El Palacio cinema, the architecture, and the mountains that he painted from his rooftop all remain.

I had much help in my search for Hopper's places

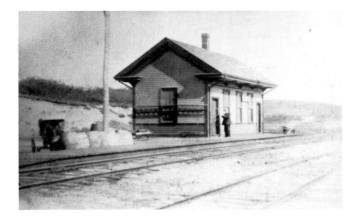

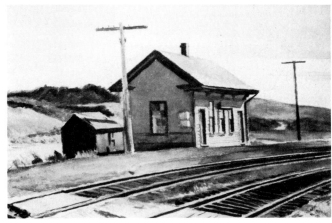

Fig. 4. *Towards Boston*, 1936, watercolor on paper, 14 × 20".

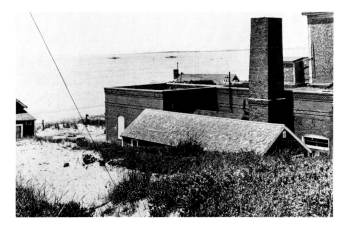

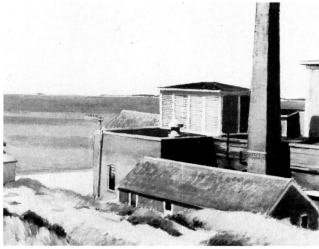

from people who volunteered leads and made suggestions in response to my work on exhibitions and publications on the artist. The problem is that many people think they have found Hopper's places when in fact they have not. Countless individuals believe that they have seen the two-story buildings of *Early Sunday Morning* everywhere in Manhattan and Brooklyn, but Hopper's original title for this work—*Seventh Avenue Shops*—indicates that these have been cases of mistaken identity. The proprietor of a Greenwich Village candy store, about to be evicted when his landlord wanted to demolish his building, implored me to document that his shop was the location painted by Hopper in his 1942 masterpiece *Nighthawks* and should therefore be preserved. He was correct about his store being in the vicinity of the diner in *Nighthawks*, but the place Hopper described as having inspired him was surely on the empty triangular lot across the street.

Just north of Nyack, in the town of Haverstraw, New York, is a house resembling that in *House by the Railroad* (Fig. 6) of 1925. Situated just across the road from the train station, this massive example of the Second Empire style is complete with the mansard roof, central tower, front porch with double columns, and corniced windows that Hopper included in his painting.

Fig. 5. *Cold Storage Plant*, 1933, watercolor on paper, 24 × 12″.

While it is not known where the actual house Hopper painted was located, this one is certainly in a place that he could have seen. Although it is not as close to the train tracks, Hopper sometimes chose to compress space, making foreground distances disappear, as he did with the churchyard railing and street in his Gloucester watercolor *Davis House,* painted just a year later.

As Hopper had earlier invented the view out of the doorway in his family home in Nyack, we must ask if he did not also modify details in *House by the Railroad,* eliminating the surrounding buildings to create a sense of isolation. Did he extract only those essential parts of the structure that he needed and omit other, less significant architectural details to achieve greater simplicity and clarity? Although many different observers have suggested to me that the Haverstraw house was definitely the model for *House by the Railroad,* I must admit that I am not certain whether Hopper would have made such great changes in structural details as the double-story cornice on the now-projecting tower, at such an early date. If this is a case of mistaken identity, the house nonetheless embodies the spirit of what Hopper was seeking. Defining that particular mood, investigating his most characteristic sites, is what this search is all about.

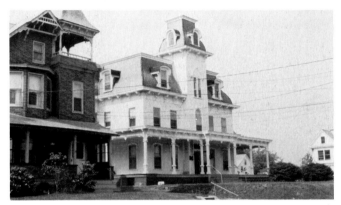

Fig. 6. *House by the Railroad,* 1925, oil on canvas, 24 × 29".

NEW YORK AND ENVIRONS

Born in Nyack, New York, a small town on the Hudson River some forty miles north of New York City, Hopper was naturally drawn to the metropolis, with its museums, art schools, galleries, theaters, and other cultural institutions. After graduating from high school in Nyack in 1899, he traveled to New York daily, taking the train and a ferryboat across the Hudson, in order to study commercial illustration. Two years later, while attending the New York School of Art, Hopper began to study painting seriously. By the time he finished art school in 1906, he was already working part time as an illustrator for an agency in the city. After his three trips to Europe between 1906 and 1910, Hopper eventually settled in a modest studio at 53 East Fifty-ninth Street, although evidently he still spent much of his time at his family's home in Nyack. By the end of 1913, he had moved to a Greenwich Village studio at 3 Washington Square North, which would remain both his home and his place of work for the rest of his life. It was only natural, then, that New York City and its environs would figure importantly in his art.

Hopper made his first views of New York in his formative years, when he painted several canvases that depict scenes along the East River: *Blackwell's Island*

(now called Roosevelt Island) in 1911, *Queensborough Bridge* in 1913, and *East River* in about 1920–1923. By 1925, he had begun to produce watercolors of New York, such as *Manhattan Bridge* and *Skyline Near Washington Square*. During the next year, he continued to work in watercolor in New York, both in lower Manhattan and from the rooftop of his building: *Manhattan Bridge and Lily Apartments, Manhattan Bridge Entrance, Roofs of Washington Square*, and *Skylights*.

While fragmentary glimpses of New York buildings appeared in canvases like *New York Pavements* of about 1924, Hopper did not return to painting oils of specific New York views until *The City*, a 1927 painting of a corner of Washington Square, which he followed in 1928 with *Williamsburgh Bridge, Manhattan Bridge Loop*, and a second version of *Blackwell's Island*. Of course, most of the views Hopper painted in New York no longer exist, as new construction has replaced the small-scale older buildings he preferred to depict. Rarely do skyscrapers occur in his art, and when they are included, it is only in partial views.

My Roof, a watercolor Hopper did in 1928, continues his recording of views visible from the roof of his building. This composition features the skylight over the

hall outside Edward and Jo's top-floor apartment. Four years later, in 1932, Hopper, working on his roof again, painted two canvases of his views: *City Roofs* (Pl. 1) and *November, Washington Square* (which he did not complete until 1959). Much of Hopper's roof view is preserved today, although some of the chimney pots have been removed and a massive new skyscraper fills the background. He probably became more interested in the view across Washington Square Park when he took over the studio facing the park in 1932, giving up his previous space in the back of the building to Jo. Although Judson Memorial Church remains intact, Washington Square below has been much altered by new construction.

During the 1930s and 40s, Hopper ventured further afield and explored New York uptown. In 1935, after many sketches along the East River, he painted *Macomb's Dam Bridge* (Pl. 4) in his studio. He also painted *Shakespeare at Dusk* (1935, Pl. 3), a view of monuments on the Mall in Central Park, with the skyline visible in the distance. In *Bridle Path* of 1939, he depicted another Central Park view, the uncharacteristic scene of three urban equestrians. *August in the City* of 1945 is set on the Upper West Side of Manhattan at Riverside Drive with Riverside Park visible in the distance. Closer to home, Hopper claimed that he was inspired to paint *Early Sunday Morning* in 1930 by shops on Seventh Avenue and *Nighthawks* in 1942 by a restaurant on Greenwich Avenue where two streets come together (Eleventh Street and Seventh Avenue). In the case of the latter, no such building has survived, while the former appears to resemble many places, none exactly right.

On occasion, in search of inspiration, Hopper took the Hudson River ferries to New Jersey, where *Sunday* (also known as *Hoboken Facade*) was set in 1926, or to Weehawken, where he made at least eight sketches for *East Wind Over Weehawken* (Pl. 2), which he painted in his studio in the winter of 1934. This street in Weehawken appears much as it did to Hopper, although the houses are painted in more subdued tones with much less polychrome. The lamp posts have been modernized, and some ornaments have changed.

Farther up the Hudson, Hopper was inspired by his hometown of Nyack, which offered a wide variety of architecture. As a boy he had sketched boats in the Hudson and painted a small watercolor of the view upriver to Hook Mountain. As late as 1949, he painted an oil of the stairway in his family's home, revealing how skillfully he combined memory with his imagination. The architecture he portrayed resembles the house (now the Edward Hopper Landmark Preservation Foundation) as it looks today. If this is not immediately apparent, it is because Hopper took the liberty of inventing verdant rolling hills, mysteriously suspended beneath an ambiguous field

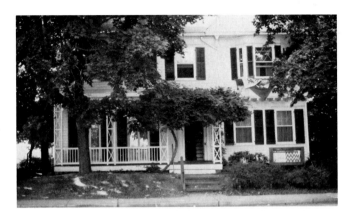

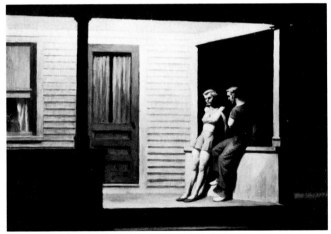

Fig. 7. *Summer Evening*, 1947, oil on canvas, 30 × 42″.

of blue, indicating either sea or sky, as the view out the front door—where one would actually see a flight of steps, the small front yard, and the street beyond. His choice of perspective, looking sharply down the stairs and out the door and then back up again, is also unusual. (Hopper would powerfully re-examine this theme in his 1951 canvas *Rooms by the Sea* [Pl. 28].) His *Summer Evening* (1947, Fig. 7) probably recalls a boyhood memory of his sister Marion, standing with a boyfriend on the porch of this house, for the basic layout of the porch structure, roof supports, windows, and door are identical.

A short walk up the street from Hopper's boyhood home in Nyack is a beautiful example of a Hudson River bracketed house, the home of Helen Hayes and her late husband, Charles MacArthur, who in 1939 commissioned Hopper to make a painting of it. Happy to have ceased working as an illustrator in the 1920s, Hopper did not enjoy working on commission. This is the only such assignment he ever accepted; that he reluctantly did so was due to the insistent nagging of his wife and his dealer, who considered this project important because of the celebrity status of the clients. Hopper made his working drawings at the house and then painted the canvas, *Pretty Penny*, in his New York studio. The result is a faithful rendering of the house he had complained he could not paint because the surrounding trees deprived it of light and air.

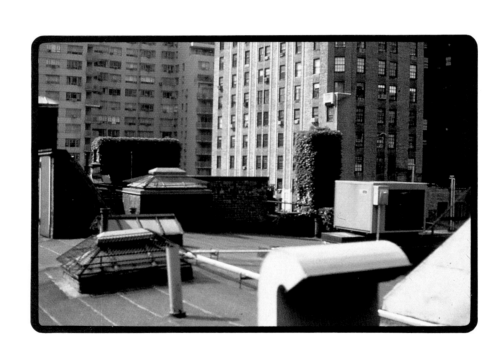

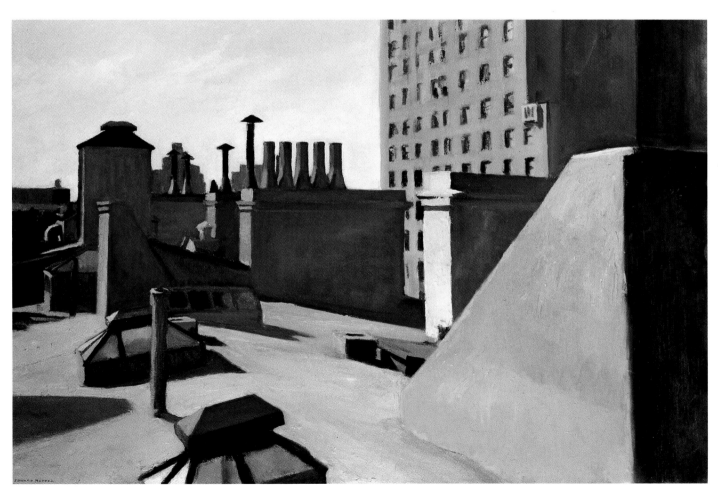

1. *City Roofs*, 1932. Oil on canvas, 29 × 36″.

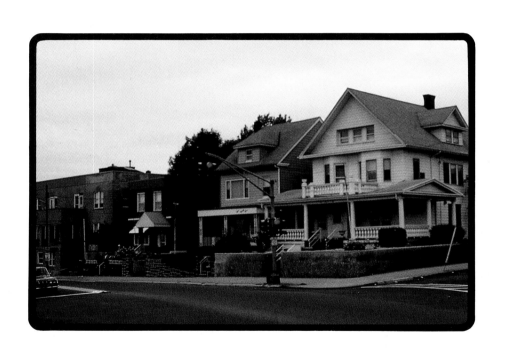

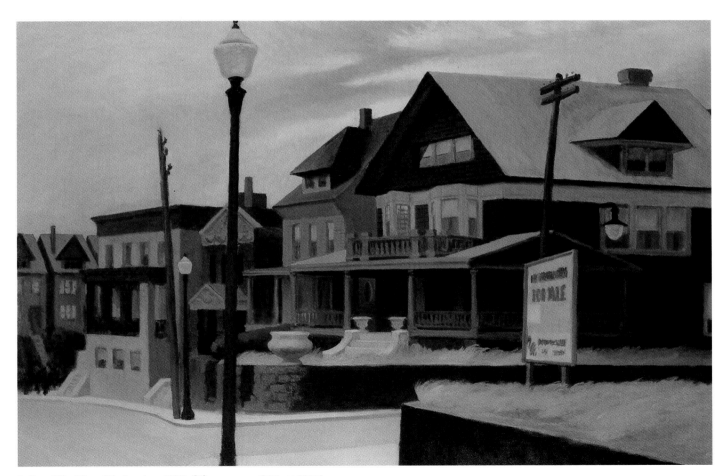

2. *East Wind Over Weehawken*, 1934. Oil on canvas, 24½ × 50¼″.

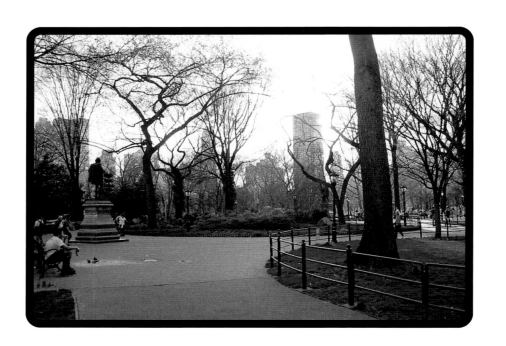

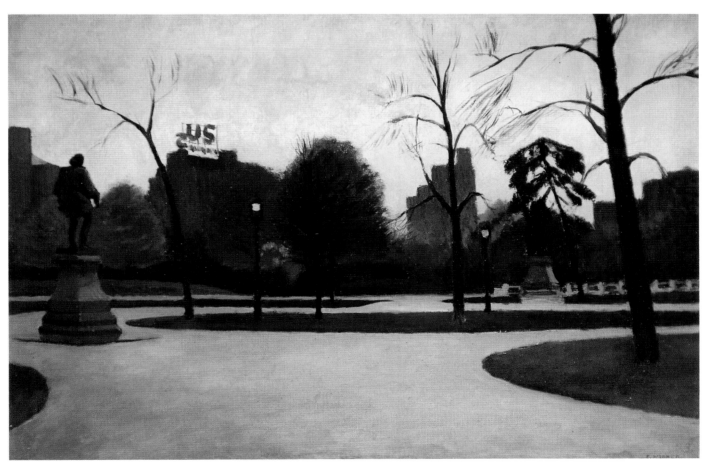

3. *Shakespeare at Dusk*, 1935. Oil on canvas, 17 × 25″.

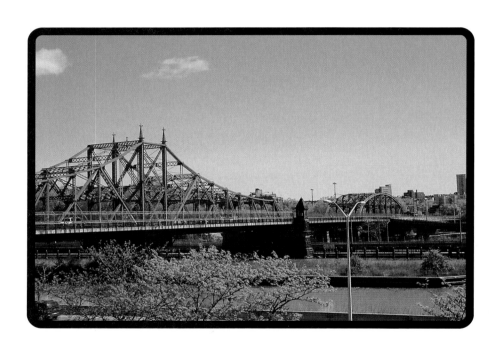

4. *Macomb's Dam Bridge*, 1935. Oil on canvas, 35 × 60³⁄₁₆″.

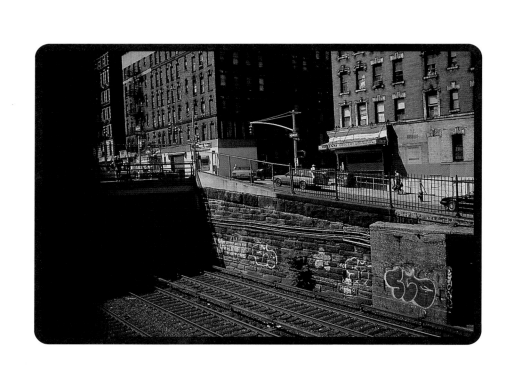

5. *Approaching a City*, 1946. Oil on canvas, 27⅛ × 36″.

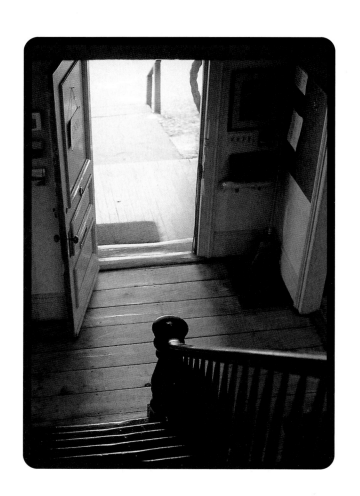

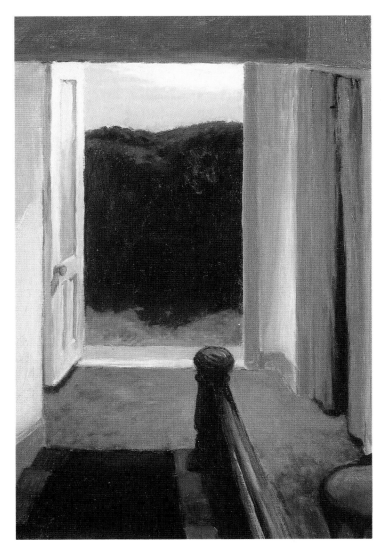

6. [Stairway], 1949. Oil on wood, $16 \times 11\frac{7}{8}''$.

MAINE

Hopper first traveled to Maine to spend the summer of 1914 in Ogunquit, a coastal town not far north of Portsmouth, New Hampshire. He returned in 1915, and the following summer he visited Monhegan Island, a small island only a mile long and located twelve miles out to sea. Hopper had certainly heard his favorite teacher, Robert Henri, describe Monhegan enthusiastically after his first stay there in 1903, just at the time of Hopper's years of study under him: "a wonderful place to paint—so much in so small a place one could hardly believe it." And he was no doubt aware of journeys there made by his former classmates George Bellows, Rockwell Kent, and Julius Golz, among others. Like Henri, Hopper produced a number of small panel paintings of the unforgettable landscape of Monhegan, which features rugged, rockbound shores, dramatic towering headlands, thundering surf with sparkling crests and deep emerald eddies, flowering meadows, and dense forests.

At the summit of Monhegan, Hopper found the island lighthouse with its surrounding buildings worthy of an oil painting. He painted the site on location, working outdoors, just as he did when he produced his views of Blackhead, Gull Rock, and other island landmarks. Although the island today is nearly unchanged from the days when Hopper painted there, the wooden buildings surrounding the lighthouse have since been destroyed by fire, leaving only the old stone foundations as evidence of the other structures Hopper included in his composition. Today only the original lighthouse tower survives, a relatively short and squat stone structure surrounded by new wooden buildings.

Hopper was so enchanted by Monhegan, with its stunning, panoramic sea views, that he returned there for the next three summers, escaping the tedium of his work as an illustrator in New York. He explained: "Maine is so beautiful and the weather is so fine in the summer—that's why I come up here to rest and to paint a little, too." He continued to enjoy summers in Maine, although he sometimes preferred to return to Cape Ann in Massachusetts instead. Eventually, however, Jo talked him into summering on Cape Cod, which he came to appreciate because it stayed warmer there longer, offering Indian summers still good for painting outdoors after the crowds of tourists had departed.

After their courtship in Gloucester in 1923 and their honeymoon there in 1924, the Hoppers spent the next summer in Santa Fe, New Mexico, returning to Maine

35

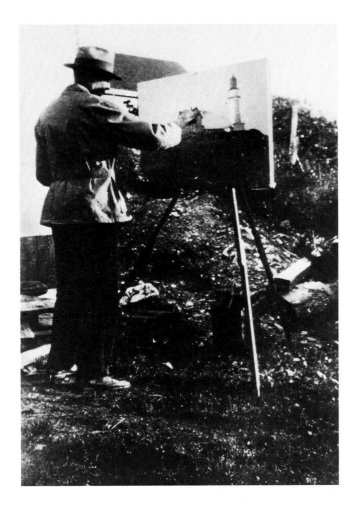

in 1926. They traveled by train from New York, arriving first in Eastport (near the Canadian border), which did not interest them. Several days later, on July 6, from Rockland, Hopper wrote to his dealer, Frank Rehn: "We did not like Eastport at all. It has very little of the character of a New England coast town. We left after three days and went to Bangor by rail and then by boat to this town, a very fine old place with lots of good-looking houses but not much shipping."

Hopper happily reported making two "sketches" within two days, announcing what was to be an especially prolific period in his career, seven weeks spent in Rockland that summer, during which he went on to paint a number of watercolors: *Haunted House* (Fig. 1), a view of an abandoned nineteenth-century boardinghouse; *Talbot's House* (Pl. 8), a fine example of a Second Empire house with a mansard roof; *Civil War Campground*, the fields where Union recruits had bivouacked in 1861; views of the harbor, the railroad, the Lime Rock quarry, and a number of different trawlers in the shipyard.

Talbot's House, identified in Hopper's records as a "fine white mansard," is almost perfectly preserved today. Located within easy walking distance of the harbor, this stately house is now a home for the aged. Shrubbery has been added, and the view through the

Fig. 8. Hopper painting *Lighthouse Hill* at Two Lights, 1927.

porch to the adjoining land is no longer foliage but another house. Hopper's vantage point for this watercolor was the front step of a house located just across this quiet street, where he probably sat with his paper and paints. In his composition, he intentionally cropped the central tower, the top of the chimney, and the base of the house, creating the sense of an imposing image continuing beyond the boundary of the paper. The style of this house was one that had particularly appealed to Hopper over the previous three years, beginning with his watercolor *The Mansard Roof* (Pl. 15), painted in Gloucester in 1923.

By the next summer, 1927, the Hoppers had purchased their first automobile and could now roam about at will, without depending on train routes and schedules. They spent much of the summer on Cape Elizabeth in Maine, at Two Lights, just south of Portland. Hopper painted various views of the Coast Guard station, the surf, the lighthouse, the keeper's house, and the pictures titled *Lobster Shack* and *House of the Fog Horn* (Fig. 9). In nearby Portland, he also found a number of places to paint: the U.S. custom house (Pl. 13), the Libby house (Pl. 14), the lighthouse, the keeper's house, and the rocky shore. Uncharacteristically, he chose examples of outstanding architectural monuments as subjects for two of his watercolors, which usually focused on the vernacular.

Hopper was fascinated by this little Coast Guard settlement at Two Lights, which, according to Jo, got its name because it used to have a second lighthouse. Jo later explained to the owner of one of his Two Lights pictures that the families of the Coast Guard men lived in the surrounding houses, but the men had to sleep in the station. Hopper was apparently intrigued by the isolation of their lives, which must have appealed to him personally. Probably at Jo's insistence, they managed to meet the residents of the houses he painted, prompting even the reticent Hopper to title his canvas *Captain Upton's House* (Pl. 10). Jo noted in the record book that in one of his watercolors. *Hill and Houses*, Captain Berry's house was located in the foreground and Captain Upton's was visible farther up the hill.

In Hopper's oil *Lighthouse Hill* (1927, Pl. 9), the lighthouse is shown with Captain Upton's house visible on the left, a view still preserved today. *Captain Upton's House* portrays a close-up view of the house from a different vantage point, with the tall tower of the lighthouse looming up just behind it. The outhouse and covered passageway leading to it have been torn down, and the lean-to shed has been replaced by a garage. Jo had remarked in a letter just how primitive life was at Two Lights, with "water from the village pump," meaning no indoor plumbing.

While the lighthouse and the keeper's house are nearly unchanged, the landscape surrounding them has undergone radical changes. Even in the last few

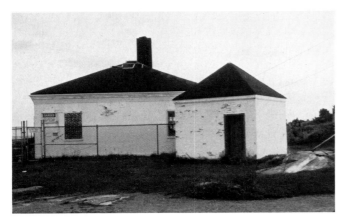

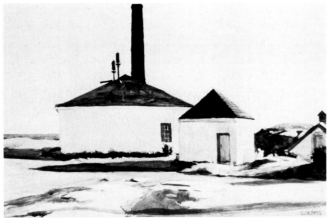

Fig. 9. *House of the Fog Horn II*, 1929, watercolor on paper, 14 × 20˝.

years, new houses have been constructed on the land nearby, blocking some of the other views that Hopper painted here. No longer dominating a lonely isolated setting, this lighthouse now rests among a group of houses, looking decidedly suburban. The two small, red-roofed, white buildings Hopper painted in his watercolors *House of the Fog Horn I* and *House of the Fog Horn II* (Fig. 9) are still much the same, except for the now-truncated chimney, the instruments, which no longer project from the roof, the new chain-link fence, and a Danger sign. Moreover, the site is now bordered by a parking lot and a popular lobster restaurant.

Hopper painted several watercolors of the Portland lighthouse: one called *Portland Head-Light* (Pl. 11), showing the lighthouse and surrounding buildings seen from the summit of a large adjacent hill, with a vast sea stretching out beyond it; one called *Rocky Pedestal,* showing the base of the lighthouse perched on high rocks; and one called *Captain Strout's House* (Pl. 12), a frontal view of the keeper's home with the tower of the lighthouse partially visible behind it, blocked by the structure of the house and cropped by the top edge of the paper. These views are remarkably preserved today. The keeper's house has been painted in different colors, the building on the left has been replaced by a garage, the foghorn on the right has been removed, a garden has been added, and the fence has been replaced by one of a more complex design; but

what Hopper recorded remains much as he saw it. The keeper's house still has a picturesque appeal linking man and the sea, which must have attracted Hopper.

In the city itself, where Hopper painted two watercolors, his subjects, the Custom House (Pl. 13) and the Libby house (Pl. 14), are well-preserved landmarks. The building that stood next to the nineteenth-century Custom House no longer exists, but even the curving utility pole still stands at the same corner location. Hopper must have liked the contrast of the angular shapes of the adjacent building with the flowing rhythms of the Custom House's graceful steps, arched windows, and cut-out fence. He abruptly cropped this large building to show only the front and the first story, in part to balance these shapes and patterns in his composition, and perhaps also to accommodate the close vantage point from which he worked on the corner across the street. Jo noted in the record book that Hopper painted this work in the rain, accounting for the pale palette, and probably indicating that he worked inside their parked car.

The Victorian mansion that Hopper depicted in *Libby House* is now a museum known as the Morse-Libby House. Until 1927, the very year Hopper painted it, the Libby family lived in this sumptuous home designed in Italian villa style in 1859 by the distinguished New Haven architect Henry Austin. In the years since, few changes have occurred: a tree is missing from the sidewalk at the side of the house, and a utility pole now replaces a large dead tree trunk that has been removed from the front sidewalk; a temporary awning has been added to the entranceway; shrubs have been planted; and a traffic sign stands on the corner. Hopper painted this scene in rather subdued tones, reflecting the strong sun bathing the structure with a harsh light. The overall composition of this house with its asymmetrical balancing of classical forms has a dramatic quality that must have attracted Hopper, who did not often select such elegant subjects. Hopper's fidelity to appearances is evident in his decision to include in his picture the very ordinary structure of the brick apartment building on the lot next door.

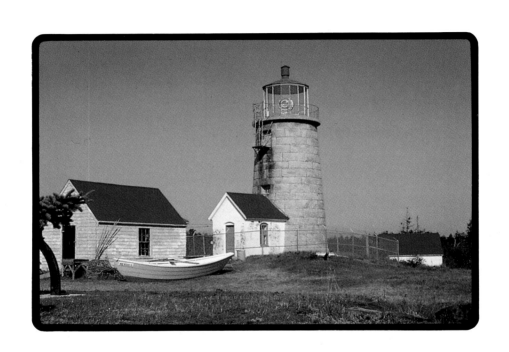

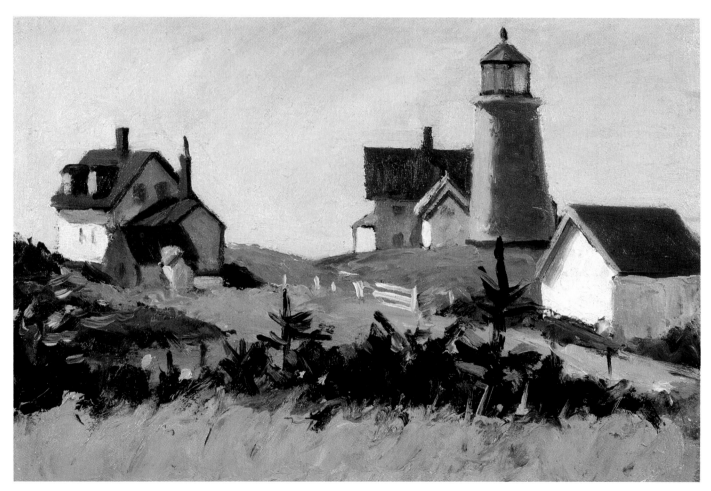

7. *Monhegan Lighthouse*, 1916–1919. Oil on board, 9½ × 12¾″.

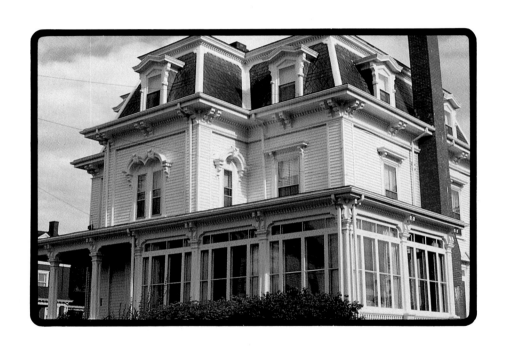

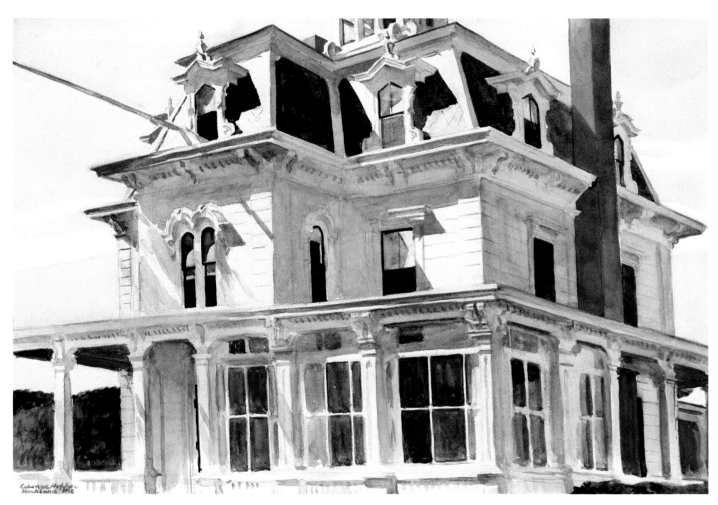

8. *Talbot's House*, 1926. Watercolor on paper, 14 × 20″.

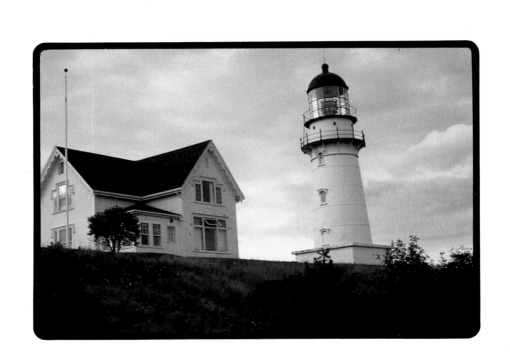

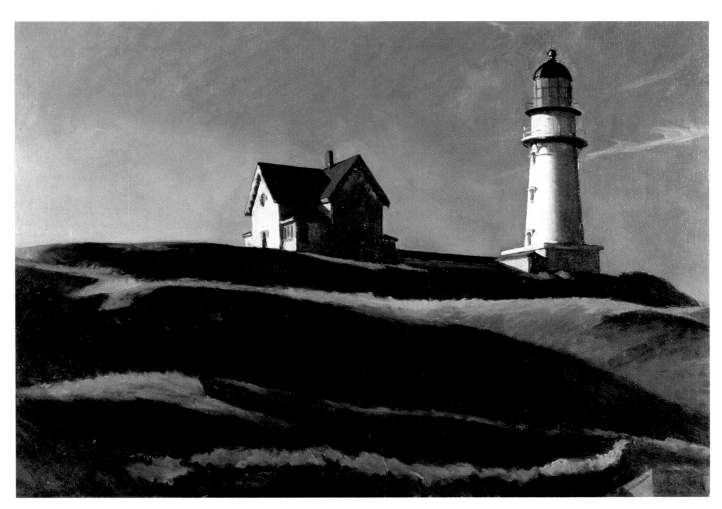

9. *Lighthouse Hill*, 1927. Oil on canvas, 28¼ × 39½″.

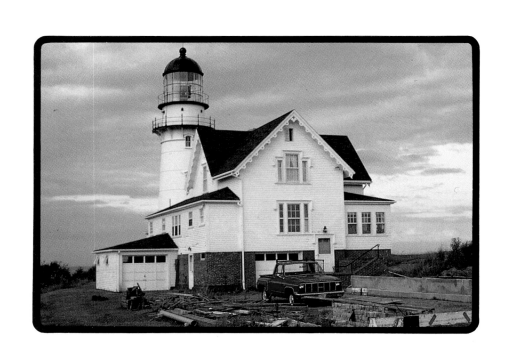

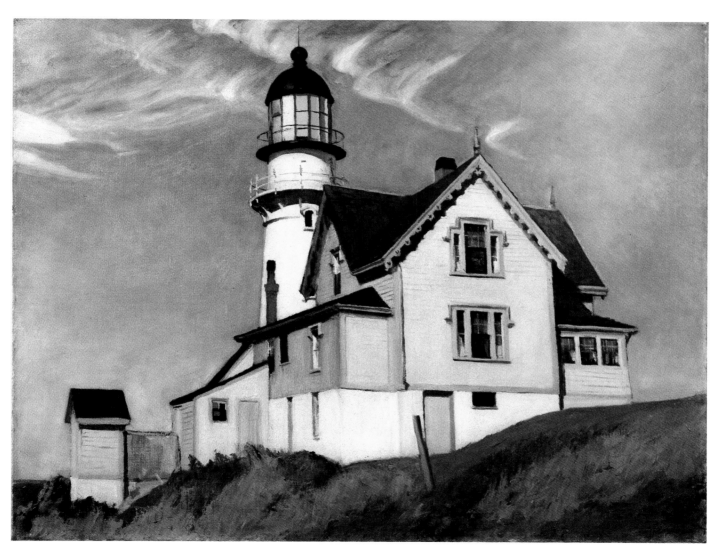

10. *Captain Upton's House*, 1927. Oil on canvas, $28\frac{1}{2} \times 36''$.

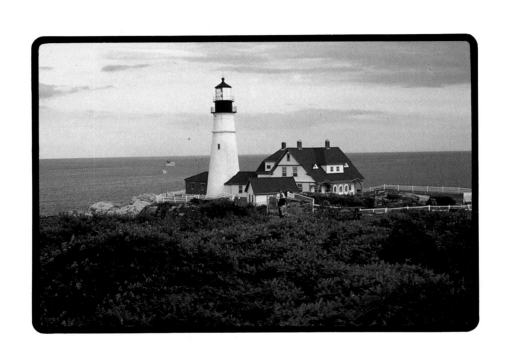

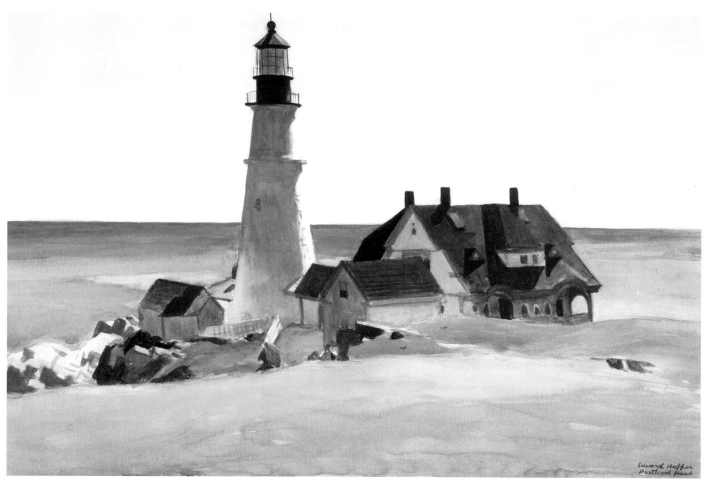

11. *Portland Head-Light*, 1927. Watercolor on paper, 14 × 20″.

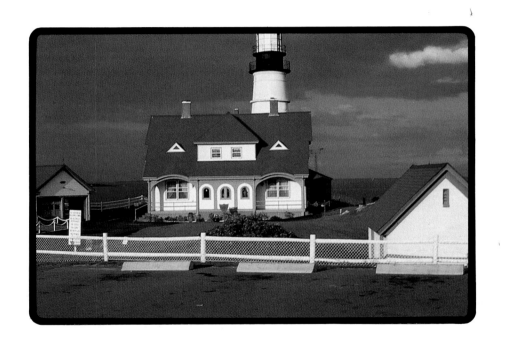

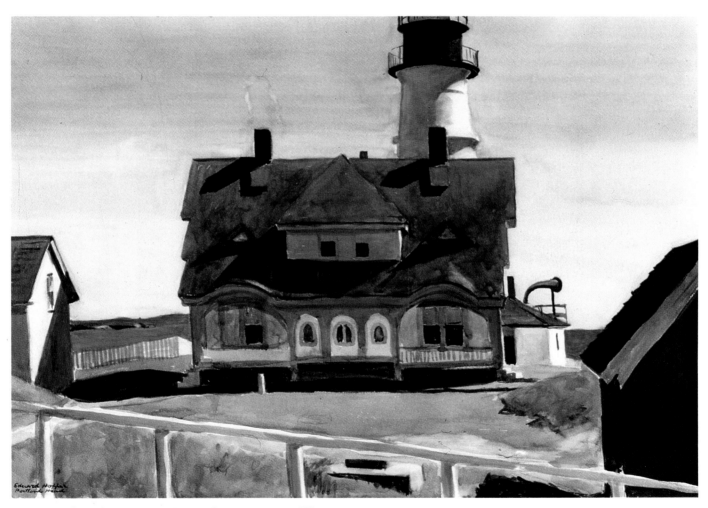

12. *Captain Strout's House*, 1927. Watercolor on paper, 14 × 20″.

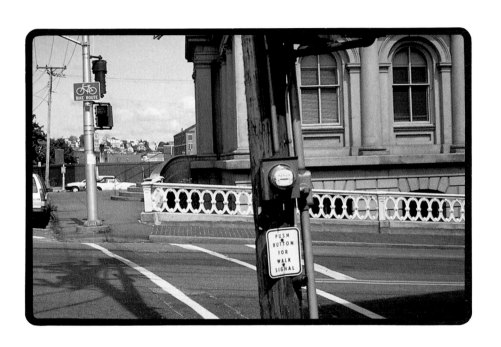

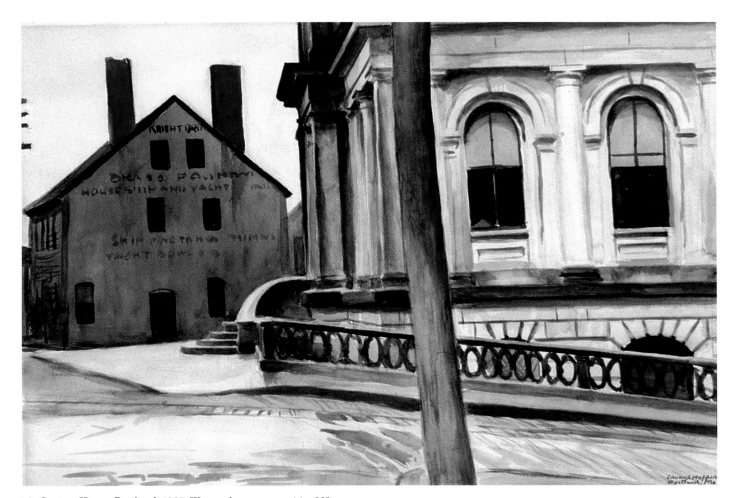

13. *Custom House, Portland*, 1927. Watercolor on paper, 14 × 20″.

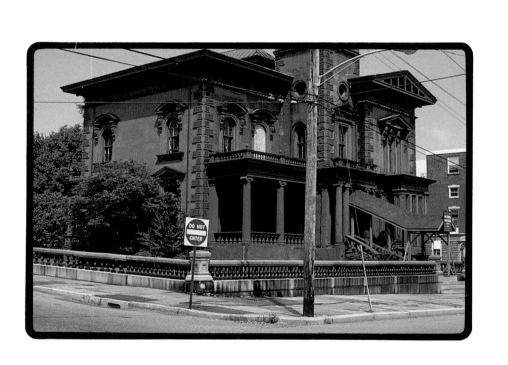

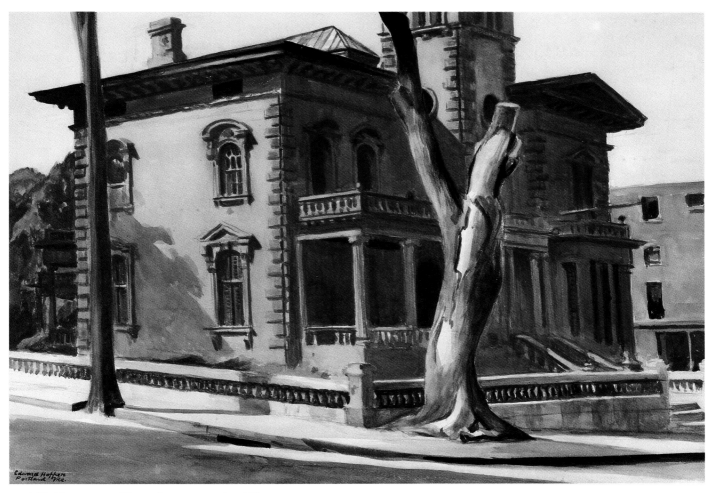

14. *Libby House*, 1927. Watercolor on paper, 14 × 20″.

GLOUCESTER

Hopper first summered in Gloucester, on Cape Ann, in 1912, where he painted with Leon Kroll, a friend from New York. That first summer he produced oils of the Italian quarter and Gloucester harbor, views that no longer exist, as the main waterfront area has changed considerably with the modernization of the fishing industry. Venturing farther afield, Hopper painted *Squam Light*, showing the lighthouse in Annisquam, just north of Gloucester. In all of these early canvases, he experimented with painting light and shadow to define structure.

Hopper was probably aware of other painters who had worked in Gloucester and of the town's history as a summer art colony. Beginning in the mid–nineteenth century, such artists as Fitz Hugh Lane, Sanford Gifford, William Trost Richards, Worthington Whittredge, Winslow Homer, William Morris Hunt, Frank Duveneck, John Henry Twachtman, and Childe Hassam had painted in Gloucester. But the Gloucester scenes Hopper certainly would have known were those by Maurice Prendergast, who had shown along with Hopper's teacher Robert Henri in the New York exhibition of "The Eight" in 1908. All of these artists appreciated Cape Ann for its intense sunlight, brightened by

the sea, and Hopper was no exception. He was also drawn to the local architecture, which offered wooden houses in a variety of distinctive styles ranging from shacks to ornate Second Empire mansions.

When Hopper returned to Gloucester during the summer of 1923 and encountered his former schoolmate Jo Nivison, he was prompted to take up painting in watercolor, if only to be a more compatible companion for their excursions. The blossoming romance and Hopper's proficiency in the medium both encouraged him to continue. He abandoned the opaque gouache that he had employed in his commercial work and explored the delicate transparency of watercolor, allowing the white of the paper to play a role in his composition. He developed a freer, more spontaneous way of handling paint and investigated luminosity with a new fervor.

That summer he spent much of his time in East Gloucester, exploring the Rocky Neck section and painting the lighthouse at Eastern Point. Jo noted in Hopper's record book that *Eastern Point Light* (Fig. 10) was his earliest watercolor painted outdoors. He chose for his location the same landmark painted earlier by Winslow Homer. The buildings that Hopper painted in

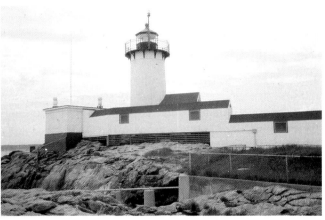

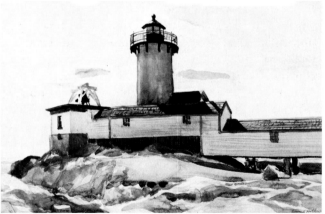

Fig. 10. *Eastern Point Light,* 1923, watercolor on paper, 14 × 20″.

Eastern Point Light are well preserved; only the bell has been replaced by automated foghorns. The dramatic rocky setting is unchanged, still a popular spot for sunbathing, swimming, or painting.

Hopper painted *The Mansard Roof* (Pl. 15) in the Rocky Neck section of Gloucester, which even today is something of an artists' colony. He described Rocky Neck as "the residential district where the old sea captains had their houses" and later recalled that it had interested him "because of the variety of roofs and windows, the mansard roof, which has always interested me...." He also noted that he had "sat out in the street ...it was very windy" and offered: "It's one of my good watercolors of the early period." Actually, Hopper's view was from the back of the house, down toward the water, which must have increased the effect of the wind he so vividly recollected. Today the house is well preserved but missing the yellow awnings that he caught fluttering in the strong breeze. The foliage has grown up so that Hopper's view can be photographed only in winter or early spring.

Hopper returned to all of the places that he had painted in Gloucester in 1912, more than a decade earlier: near the lighthouse in Annisquam, he painted *Houses of Squam Light;* in the center of the town, he painted *Italian Quarter* and *House in Italian Quarter.* He then moved on to paint in other areas of Gloucester for the first time: *Shacks at Lanesville, Portuguese*

Quarter, and *Portuguese Church* (Our Lady of Good Voyage).

When Hopper painted *Gloucester Mansion*, the side view of a large, ornate Second Empire house set on a hill overlooking Gloucester harbor, and a year later painted this same imposing house in a frontal view as *Haskell's House* (Fig. 2), he was working in a location not far from where he painted his 1912 oil *Gloucester Harbor*, but his interests had led him to something much more personal than the picturesque harbor captured by so many artists before him. He now focused on this ornate hybrid style of American architecture which Jo called "the wedding cake house," a fitting subject for a work painted on their honeymoon.

Although painted in a completely different color scheme, the structure of this house today is just as Hopper depicted it. Yet the overall appearance is so changed that one does not initially recognize it. Unlike the house of *The Mansard Roof*, still set in a quiet corner of Rocky Neck, this once stately house is on one of busy Gloucester's main thoroughfares, overlooking the now industrialized harbor. The short shrubs that once lined the long steps leading up the hill to the house have been replaced by tall fir trees which totally block the view that Hopper painted.

Jo and Edward returned to Gloucester in autumn 1926, after their seven-week stay in Rockland, Maine, and remained there through October. Hopper worked in the center of town, concentrating on individual houses, with occasional ventures farther afield, to paint *House by Squam River* and *Trees, East Gloucester*, which he rendered in an unusually free and fluid style that Jo described as "wild and wooly."

More characteristic of this visit is *Anderson's House* (Pl. 17), which depicts a typical Gloucester three-story wooden house raked by sunlight. Today it is painted a different color and missing its shutters, but even the surrounding houses are intact, although the one in the distance no longer has a red roof. At the top of his composition, Hopper cleverly cropped the house's gable, pushing the viewer's eye back down to the repeated rectangular shapes below.

On Middle Street, across from the Davis house (Pl. 18), Hopper found a convenient churchyard in which to work without intruding on someone's front steps as he had in Rockland while painting *Talbot's House*. He later said that so many artists were working in front of the Davis house painting the church that he decided to sit in the churchyard and paint the house! The house is now white and the trees are gone, replaced by low shrubbery. Hopper compressed the pictorial space, so that the railing alongside the churchyard appears to be directly in front of the house instead of across the street. By cropping the house along the left side, he created a sense of continuity, the feeling that the scene goes on beyond the boundaries of his composition.

During September, working outdoors at the nearby corner of Church and Pine streets, Hopper painted *Gloucester Street* (Pl. 16), depicting three houses with gables in the foreground and a fourth building in the distance. This canvas resembles the watercolors in subject matter and composition, with cropped buildings on both sides. Today, except for color, this row of houses appears much the same as it did to Hopper. Only incidental changes have occurred: the picket fence across the street is now chain link; the houses have lost their shutters; arched windows have been replaced by cheaper rectangular ones; picket fences and railings have been added. The play of sunlight falling on the architecture still animates the scene with light and shadow, although the bright polychrome Hopper depicted has now been replaced by a uniform white, calling less attention to the houses' eccentric forms and individuality.

In 1928 the Hoppers spent their last summer in Gloucester, and Edward not only painted watercolors but also produced three canvases: *Freight Cars, Gloucester; Cape Ann Granite*, a view of a rocky pasture; and *Hodgkin's House*, located on the road to Annisquam. The watercolors Hopper painted at this time also include scenes of a pasture, railroad gates, a box factory, and a circus wagon, as well as the usual views of local streets and houses. The latter are well preserved today, looking very much as Hopper recorded them.

House on Middle Street (Pl. 19) records Hopper's return to the same road where he painted *Davis House* two years earlier. Although painted in different colors, this house looks nearly identical to Hopper's image except that he made it appear proportionately less wide and it is now missing its shutters and striped awnings. The grassy area to the left is now a paved driveway with steps leading down to it; on the right, the houses in the distance are painted brighter colors, and a tree has been added. It is interesting to note that even the utility pole on the right side remains in the identical position.

Prospect Street still appears as it did when Hopper painted it in 1928 (Pl. 20), with the towers of Our Lady of Good Voyage in the distance. The sun porch of the house in the foreground has been enclosed, and other houses on the street have new roofs and different colors, but the basic look remains the same. Street lamps and traffic signs have been added; the tops of the church's twin towers are now bright blue; and the cars are updated from the 1920s. Light and shadow still play upon the rhythmic shapes of gables, roofs, projecting doorways, and dormer windows to create the varied composition of visual shapes that appealed to Hopper.

The subject of *Adam's House* (Pl. 21), situated on a high hill overlooking the town below, also remains just about as it looked when Hopper painted his watercolor. Even the locations of the yellow fire hydrant and the

utility pole are unchanged. Only the ornament that hung over the doorway is missing, replaced by an additional pair of shutters and a trellis at the entrance. The large tree in the yard on the left has disappeared, and the style of the picket fence has changed; but the view of Gloucester beyond is essentially the same. The contrast of the foreground with the distant panoramic view of the town below makes this a particularly interesting composition.

We might ask why Hopper, after so many fruitful experiences in Gloucester, was never again to spend any time painting there after the summer of 1928. A brief visit to friends in Ogunquit that summer probably prompted him to return to Maine for the summer of 1929, and the next year Jo finally persuaded him to try Cape Cod. Then, too, it is more than likely that Hopper had begun to be a bit bored with Gloucester, which, after all, he had thoroughly explored. New places meant fresh stimuli for him, and he often felt the necessity to go out and seek such inspiration.

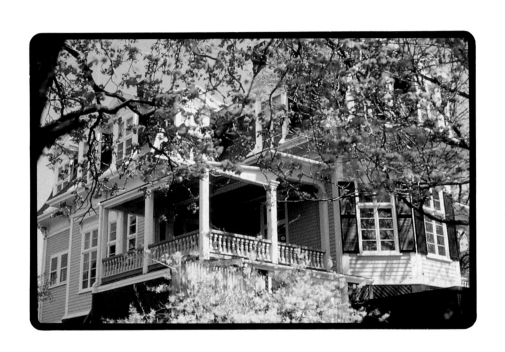

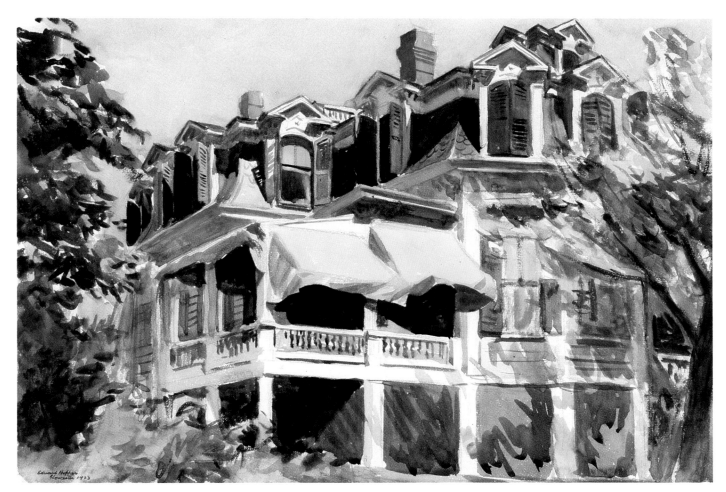

15. *The Mansard Roof*, 1923. Watercolor on paper, 13¾ × 19″.

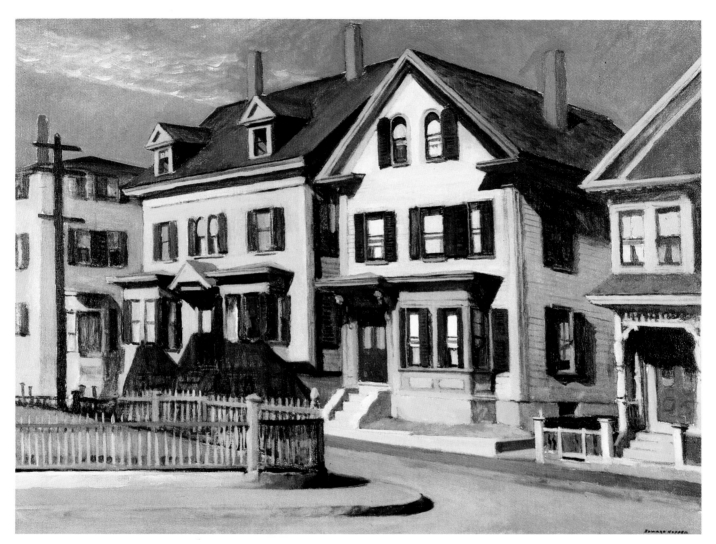

16. *Gloucester Street*, 1926. Oil on canvas, 28 × 36″.

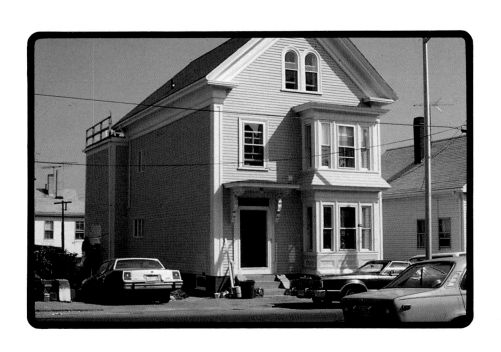

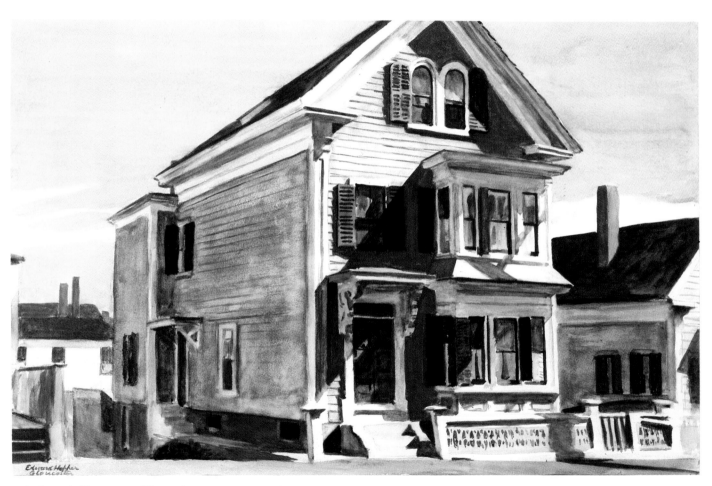

17. *Anderson's House*, 1926. Watercolor on paper, 14 × 20″.

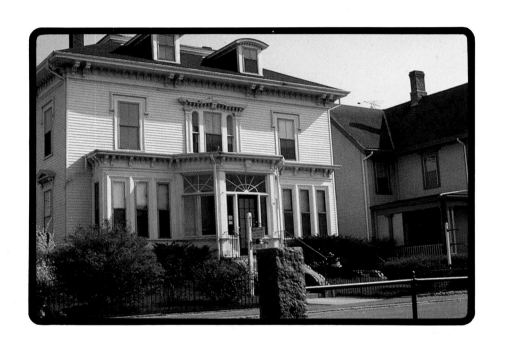

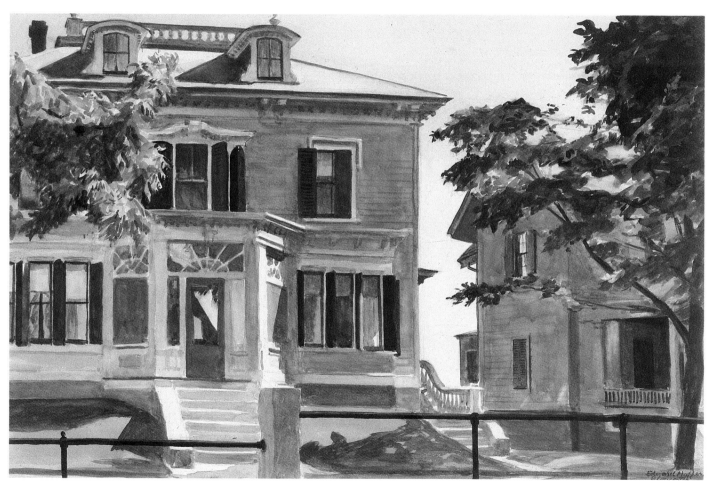

18. *Davis House*, 1926. Watercolor on paper, 14 × 20″.

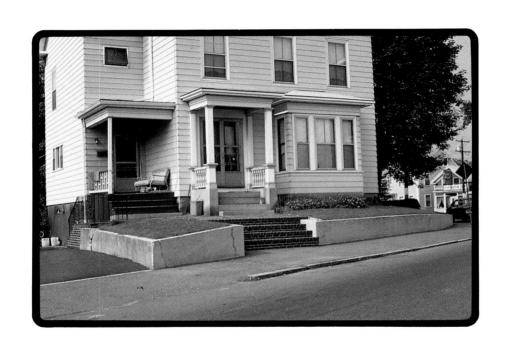

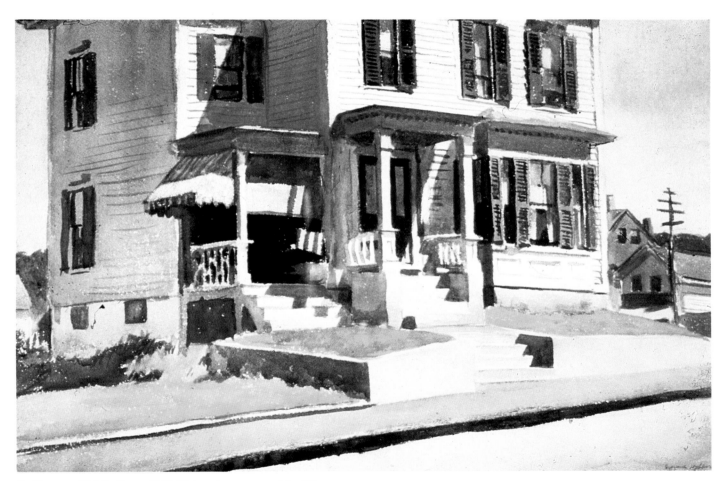

19. *House on Middle Street*, 1928. Watercolor on paper, 14 × 20″.

20. *Prospect Street, Gloucester*, 1928. Watercolor on paper, 14 × 20″.

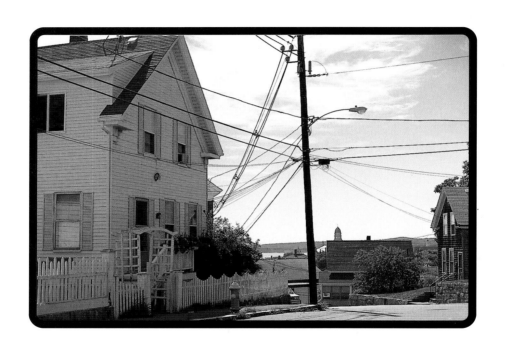

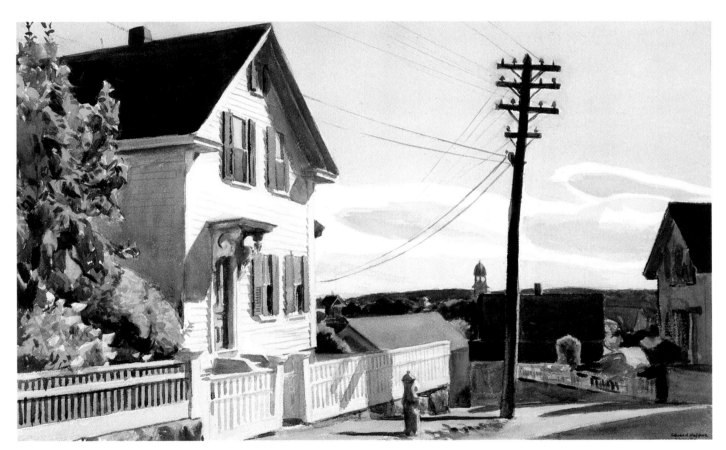

21. *Adam's House*, 1928. Watercolor on paper, 16 × 25″.

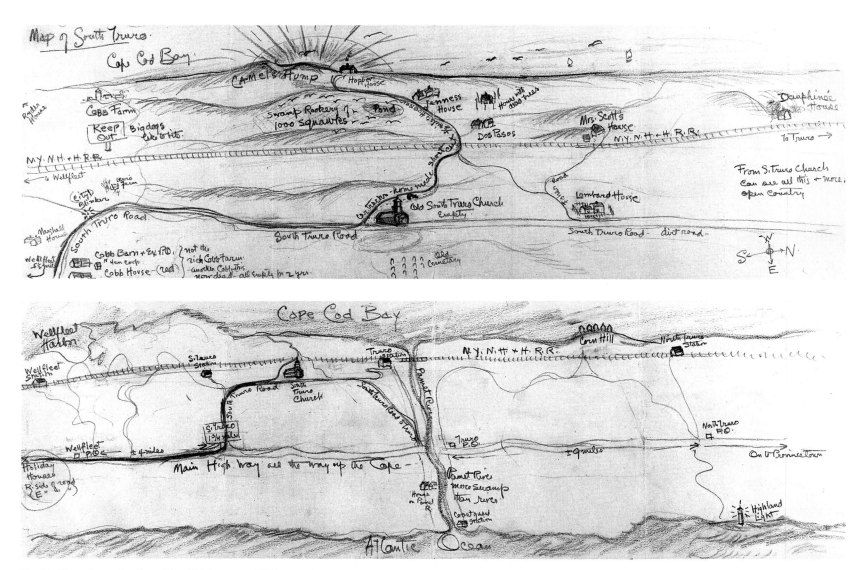

Fig. 11. Maps drawn by Josephine N. Hopper, c. 1934.

CAPE COD

In the summer of 1930, the Hoppers drove out to the East End of Cape Cod and rented in South Truro a modest cottage, which Jo described as "on the side of a hill in such a wonderful land of bare green sandy hills." They returned to this small, isolated house for the next three summers and came to call it "Bird Cage Cottage," because rain, wind, and animals entered it with equal freedom. Jo described their summer home as being "as primitive as the land it's in." The unusually bad weather during the summer of 1933 and a small, unexpected inheritance from Jo's family encouraged the Hoppers to build their own simple South Truro home with a studio space that enabled them to paint indoors. Situated on a cliff overlooking the bay, the new house, which Edward designed, was completed in the summer of 1934, at the time of their tenth wedding anniversary. It was not, however, until 1954 that they added electricity.

During his first years on Cape Cod, Hopper was inspired to depict his new surroundings, often recording them from the vantage point of his automobile. He walked and drove around finding many vistas that appealed to him. These included the tiny local railroad station (Fig. 4), the post office, buildings on the farm owned by their landlord, Burly Cobb, neighboring houses, farms, roads, the lighthouse in North Truro, and the bridge in nearby Wellfleet. He drove all the way to Provincetown, on the tip of the Cape, and there painted the Methodist Church tower and some of the local houses. He often painted along the railroad embankment and depicted the tracks crossing this remote countryside of Cape Cod's East End. Although Hopper never painted a view of the house he designed, Jo made various sketches and paintings of what she referred to as "Chez Hopper."

Some of the most imposing structures on Cape Cod have disappeared since Hopper depicted them, just as his views of the landscape have been changed by the unrelenting forces of nature. In 1930, he and Jo both painted views of the South Truro Church, which burned down in 1937. In North Truro in 1933, he painted an imposing, factorylike structure used as a fish warehouse until it was torn down (Cold Storage Plant, Fig. 5). Yet nature still held some interest for Hopper, and he occasionally depicted landscapes with cows grazing, sand dunes, or trees, although the latter were sometimes shown dead. It was not long, however, before he grew bored with the scenery that he had come to know so intimately.

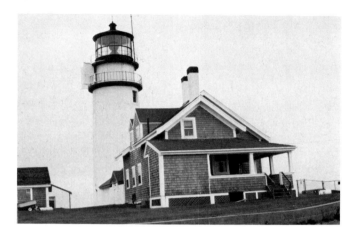

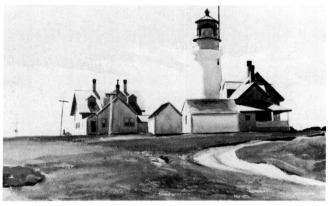

Fig. 12. *Highland Light*, 1930, watercolor on paper, 16 × 25".

The North Truro lighthouse tower and keeper's house that Hopper depicted in a 1930 watercolor, *Highland Light* (Fig. 11), remain much as they were when he painted them, although some of the smaller outbuildings have been removed and fences have been added, blocking access and his original vantage point. The drama of this isolated spot overlooking the sea remains, as do the explosive Cape skies which silhouette the lighthouse tower.

The model for *Rich's House* (Pl. 22), in South Truro, looks much the same as when Hopper painted it in 1930. The new roof is a different color, and a large tree and some shrubs have grown up beside the house. Only the base of the windmill tower still stands, and the white picket fence is now of a slightly different design. In 1931 Hopper returned to this farm and painted the barn, another large white structure. As in almost all of Hopper's Cape Cod paintings, the forms are defined by the Cape's intense sunlight, which almost evokes the sense of being at sea.

Hopper painted *Dauphinée House* (Fig. 12) on canvas in 1932, having portrayed the subject in watercolor as *Captain Kelly's House* a year earlier. Jo, too, produced an oil of this house, which stood just by the railroad tracks, only a short walk from their home. Hopper painted it in watercolor once again in *Railroad Embankment* (1932). Eventually, the house was purchased by Hopper's friend and fellow artist Henry

Varnum Poor. Although grey shingles have been added to one side of this house, the shutters are painted a darker color, and shrubbery has been planted, the house still stands alone, isolated in a clearing, its simple geometric structure in sharp contrast to the gentle curves of the surrounding hills.

The Hoppers' nearest neighbors on the Cape were the Jenness family (Kelley, Harriet, and their daughter, Virginia), who came down every summer from Boston. They gave the Hoppers the use of their home for over two months during the spring of 1934, when Edward and Jo wanted to be present for the construction of their new house. Hopper, in exchange for this and the right-of-way over the Jennesses' land, promised to paint them a watercolor, a view of their home, which he had first depicted as *Kelley Jenness House* in 1932. Eventually, Hopper kept his promise, although this commitment weighed upon him, as he was reluctant to produce anything on demand. Today the simple structure of the Jenness home, set in the gently rolling hills, appears much the way it looked when Hopper painted his four versions of it (Pl. 23). Only the chicken coop or shed on the right side has been removed, and the new roof is a different color. The tall timothy grass, which grows abundantly in the sandy Cape soil, still turns the same golden-brown tones that Hopper painted.

Remarkably, the weather-beaten shacks in *Near the*

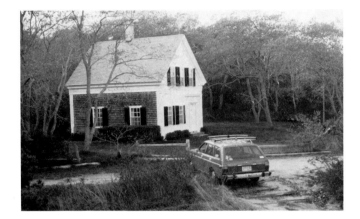

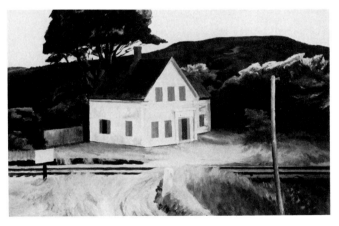

Fig. 13. *Dauphinée House*, 1932, oil on canvas, 34 × 50˝.

Back Shore (Pl. 24), a watercolor of 1936, have survived almost exactly as Hopper painted them nearly fifty years ago. Even the utility pole appears to lean at the same precarious angle. The sand dunes he depicted lead to the ocean beach in Truro, where Hopper did not often go, as he enjoyed swimming at the convenient bay beach just below his own house, and perhaps preferred to avoid other people, who were more likely to frequent the more beautiful ocean beach.

Hopper painted two watercolors of a house at the end of Station Road (today called Depot Road), not far from his home: *House with a Rain Barrel* (1936) and *Mouth of Pamet River—Fall Tide* (1937, Pl. 25). He wanted to depict the flood tide in the latter version, but he had to work fast, as the tide was quickly changing. He was also interested in other aspects of this bare, isolated setting, particularly the high sea grass in the surrounding meadows. Today the structure of the house remains relatively unchanged, but trees and shrubs have tamed the character of these once wild meadows, altering the somber mood and dramatic effect of the landscape that originally attracted Hopper.

And progress has not always been kind to Cape Cod. Development has reached even the more remote areas on the far end of the Cape. New houses now crowd the once spare landscapes Hopper knew, blocking the vis-

Edward and Jo Hopper on Cape Cod, c. 1930.

tas. Hopper painted *Cottages of North Truro* (Pl. 26) in 1938, and everything he depicted survives; however, a new house has been inserted into the landscape. The railroad no longer goes to Cape Cod; the tracks he once painted in a canvas called *New York, New Haven, and Hartford* have been removed. The embankment and the track beds linger on, serving no purpose, however, but merely marking the landscape.

The quaint Provincetown boardinghouse on Bradford Street that Hopper captured in 1945 in *Rooms for Tourists* (Pl. 27) looks unchanged today, with the exception of the colors of the shutters and awnings and the position of the sign. Hopper depicted this house at night, contrasting the inviting, illuminated interior with the ominous darkened street outside. As with most of his later oils, Hopper made his preliminary drawings while sitting in his car and then produced the painting in his studio.

In 1951 Hopper produced *Rooms by the Sea* (Pl. 28), one of his most unusual paintings, inspired by the real view through the door of his Cape Cod studio. Looking out, one actually sees across the edge of the dunes to the vast expanse of the bay; but at Hopper's artificially chosen angle, only the sky and the water are visible—a magical vision of a doorway dropping off directly into the sea. Although the room visible in the distance is located in a spatial configuration identical to the Hoppers' bedroom, he moved the hinge of the outside door from the left to the right side. Here reality has been adjusted to serve the artist's fantasy, yielding to his imagination. In this work Hopper created a memorable drama evoking untold mystery.

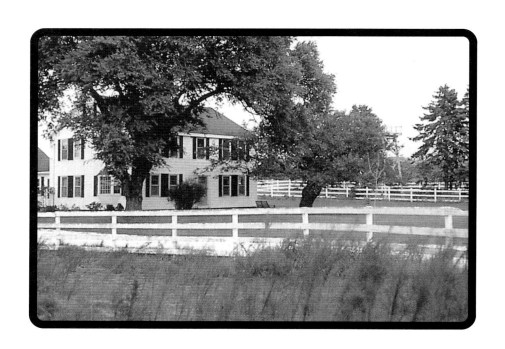

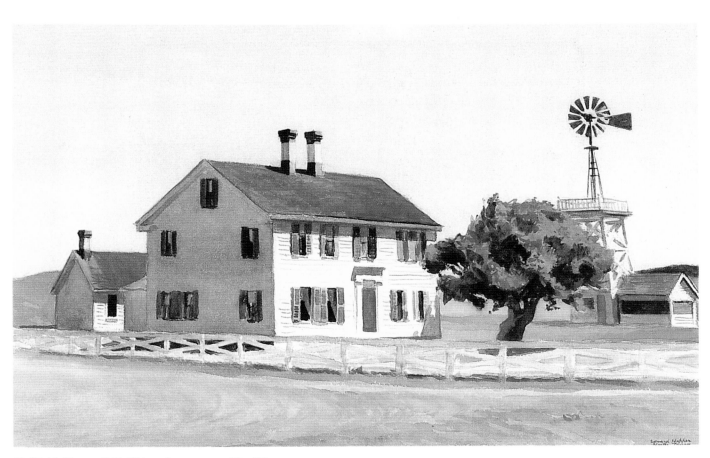

22. *Rich's House*, 1930. Watercolor on paper, 16 × 25″.

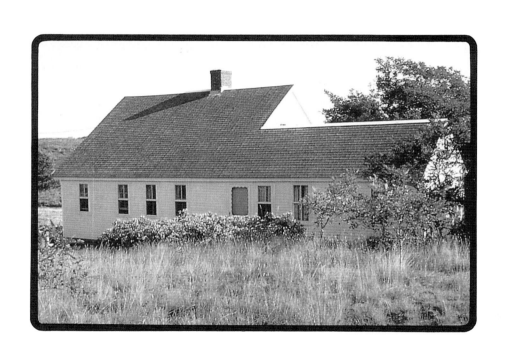

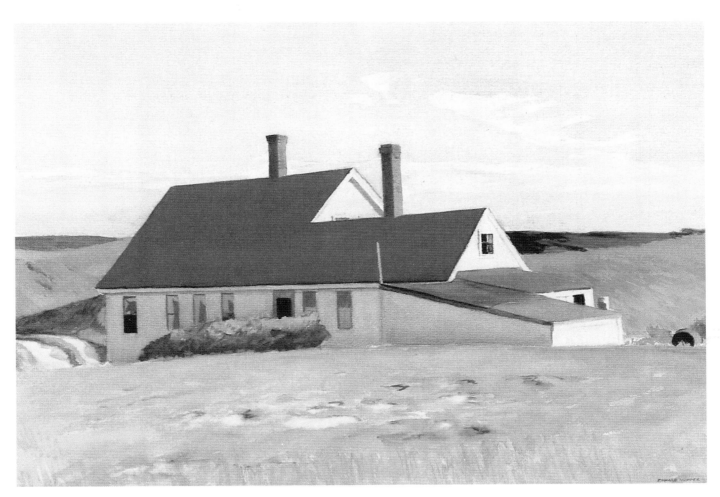

23. *Jenness House Looking North*, 1934. Watercolor on paper, 20 × 28″.

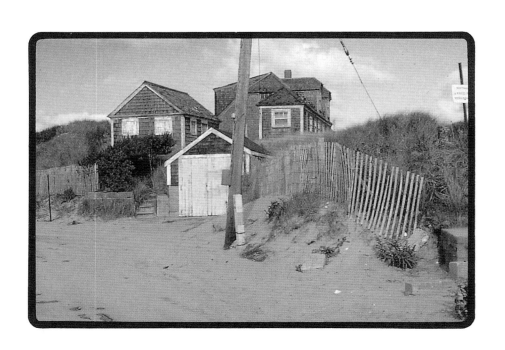

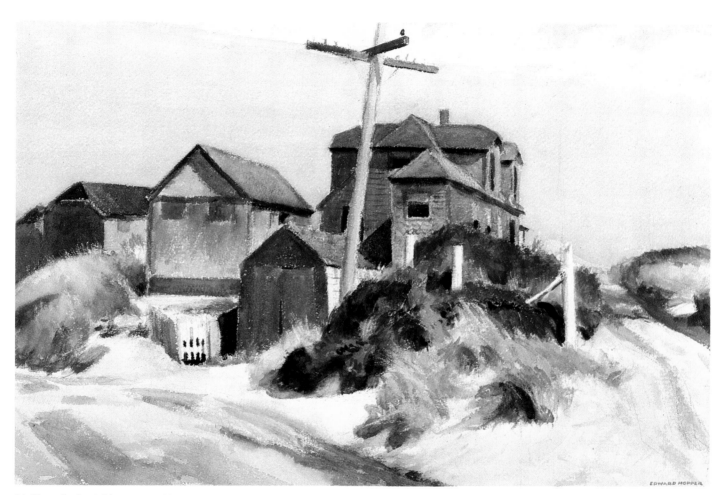

24. *Near the Back Shore*, 1936. Watercolor on paper, 14 × 20″.

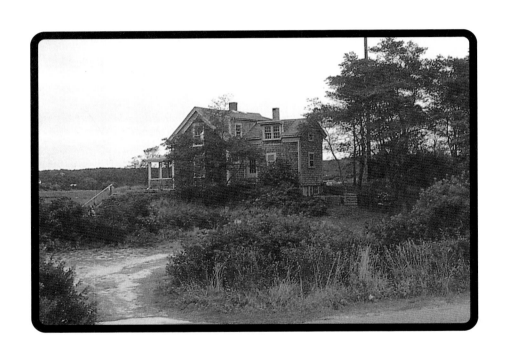

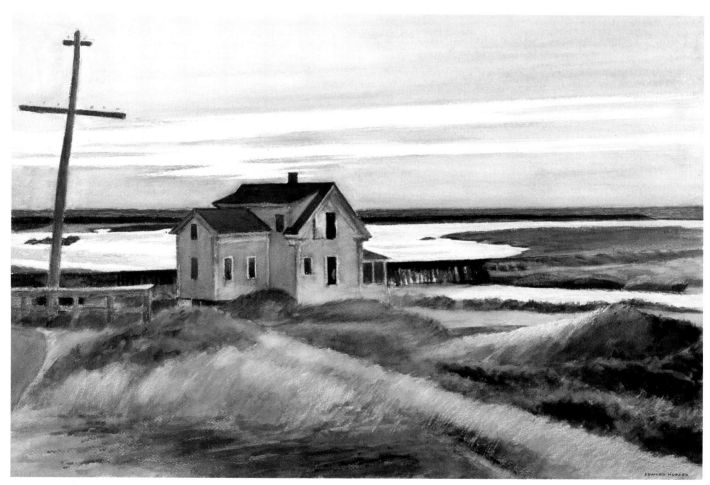

25. *Mouth of Pamet River—Fall Tide*, 1937. Watercolor on paper, 20 × 28″.

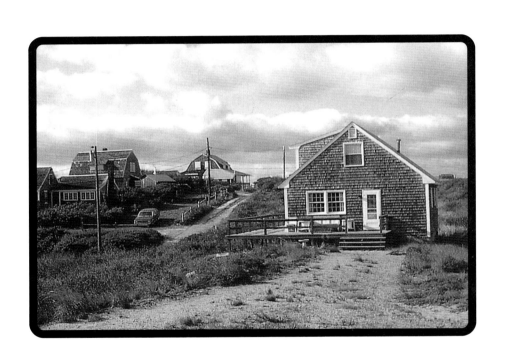

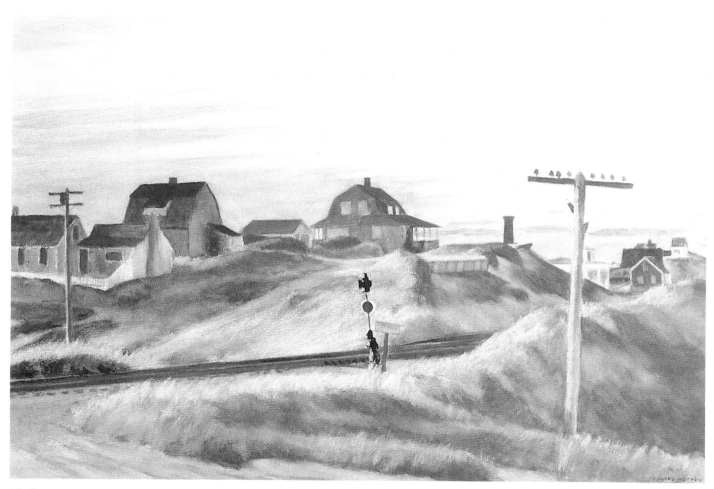

26. *Cottages at North Truro*, 1938. Watercolor on paper, 19¾ × 27¾″.

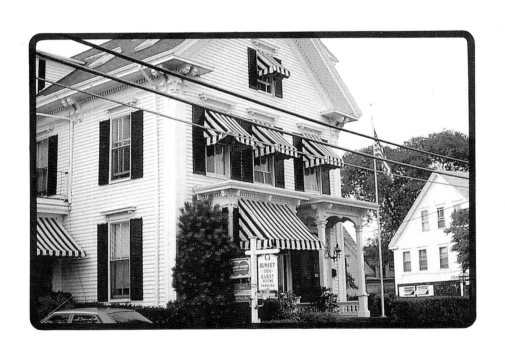

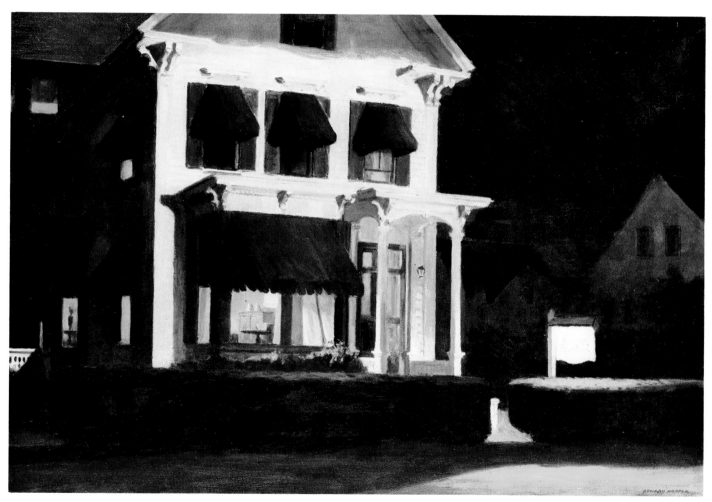

27. *Rooms for Tourists*, 1945. Oil on canvas, 30 × 40″.

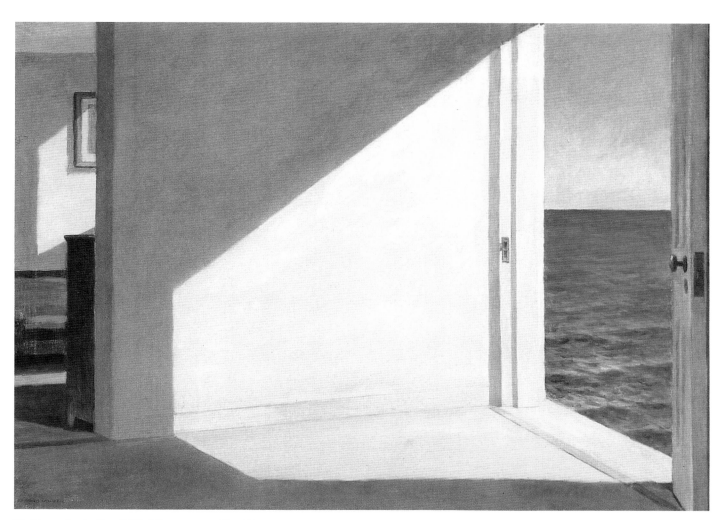

28. *Rooms by the Sea,* 1951. Oil on canvas, 29 × 40″.

GETTYSBURG, PENNSYLVANIA

Hopper and his wife visited Gettysburg, Pennsylvania, in May of 1929, going out of their direct way home to New York from Charleston, South Carolina, so as not to miss one of the most celebrated battlefields of the Civil War. Gettysburg represents a defining moment in the war and as such must have held special appeal for Hopper. As a boy in Nyack he would have looked in awe at the picturesque long beards of the veterans of the Grand Army of the Republic, marching in the annual parades and conversing on benches downtown. He made drawings of the war and cut out and painted paper soldiers, which suggests how large the war loomed in his imagination. His father, Garret Henry Hopper, born in 1852, had lived through the terror and danger of the draft riots that took place in New York City in 1863, when he was only eleven. Having had his youth marked by such turbulent wartime events, Garret must have fostered young Edward's fascination with the war. Its memory also survived in American culture through documentary photographs and works of art, from commemorative sculpture to Winslow Homer's illustrations and paintings, as well as through public ceremonies and festive reenactments.

So vital was the memory of Gettysburg that Congress in 1895, when Hopper was thirteen years old, established a National Military Park. Just when young Edward was making his model soldiers, Congress commemorated the climactic three-day battle fought in July of 1863. Up to that time, during the first two years of the war, the South had been winning victories. Gettysburg turned the tide. In the bruising struggle, both the Union and Confederate armies suffered heavy casualties. More than ten thousand men had been killed or died of wounds in the small town before the Union troops finally succeeded in demoralizing their opponents. The Confederate army was so debilitated that never again was it able to take the offensive. On this site, when the Soldiers' National Cemetery was being dedicated the following November, Edward Everett Hale delivered the lengthy oration that has been forgotten and Abraham Lincoln gave his succinct and unforgettable address. Gettysburg had prepared the way to the end of the war, although not until

April 9, 1865, would Robert E. Lee surrender to Ulysses S. Grant at Appomattox Court House.

Hopper, the inveterate aficionado, had toured Civil War sites during his stay in Charleston. Although he made a point of the pilgrimage to Gettysburg on his return northward, no evidence survives that he worked on site. Nearly five years would pass before his Gettysburg pilgrimage would crystallize into a painting. Such a delay was not unusual, for Hopper's ideas often required a lengthy period of rumination. It was not until late February 1934 that he finished *Dawn Before Gettysburg* (Pl. 29), the first of the two canvases that he painted about the Civil War. Six years later, he produced *Light Battery at Gettysburg*, another canvas inspired by this same momentous time and place. These were also the only two history paintings he ever made. He did, however, paint two Civil War watercolors: *Civil War Campground* (1926) in Rockland, Maine, and The Battery, Charleston (1929, Pl. 30).

Hopper was clearly moved by his visit to the simple white clapboard house that had served as the Union Army Headquarters for General George G. Meade. It is a mark of Hopper's preference for painting what he could directly observe that this image makes an appearance in *Dawn Before Gettysburg*. The small house is also known as the Leister house for its then owner, the widow Lydia A. Leister. Located on the western side of the Taneytown Road

Fig. 14. *Light Battery at Gettysburg*, 1940, oil on canvas, 18 × 27″.

just south of Cemetery Hill, the house had also figured importantly in wartime photographs by Alexander Gardner and the Tyson Brothers. Hopper chose his own observed point of view rather than working from a photograph; yet he rendered the landmark house so faithfully that it is readily recognizable from his painting.

It is also a measure of the fascination the subject held for Hopper, that to the scene he had observed he added the images of soldiers, which he could have seen in photographs made during the war by Gardner and others. Precisely which photograph inspired Hopper or where he found it remains unknown. Jo

Fig. 15. "General Torbert and His Staff, 1864," *Photographic History of the Civil War*, 1911.

did not give him Francis T. Miller's monumental ten-volume *Photographic History of the Civil War* (which she purchased second-hand, since it was published in New York in 1911) until the summer of 1936, though she clearly knew of his enthusiasm for Civil War history, for Mathew Brady's photographs, and, possibly, for this specific set of books. With a concern for historical accuracy, Hopper depicted the soldiers with their rifles (known as muzzle loaders), resting at dawn before the battle began later that morning of July 1, 1863. He subsequently commented on what he admired in Brady's photographs:

"There was something about the way he took pictures. Somebody said it was the lens they had in those days—not sharp. But anyway the pictures aren't cluttered up with detail; you just get what is important. Very simplified."

Brady, according to studies completed long after Hopper painted his two history pictures, was sometimes erroneously given credit for Civil War photographs taken by others. At least some of the work Hopper admired as by Brady may actually have been by Gardner, Timothy H. O'Sullivan, or other photographers, yet his appreciation of these Gettysburg photographs is certain.

Hopper's decision to add soldiers to the actual place he had observed makes *Dawn Before Gettysburg* unusual, if not unique, in his work. That he chose to show the soldiers resting rather than in action reflects his own temperament. Many times, both before and after this painting, he depicted people who appear to be tired or bored as they sit and wait, as for example, in *Sunday* (1926), *French Six-Day Bicycle Rider* (1937), *Summer in a City* (1949), or *Sea Watchers* (1952). In her record book entry on *Dawn Before Gettysburg*, Jo noted: "Soldiers, very young in dark blue coats & lighter blue pants. Positions, sleepy & fatigued. 2nd from L. [left] fixing shoe, foot sore. Little officer with white stripe down pants with sword."

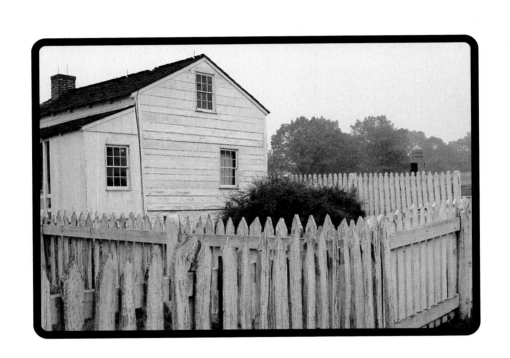

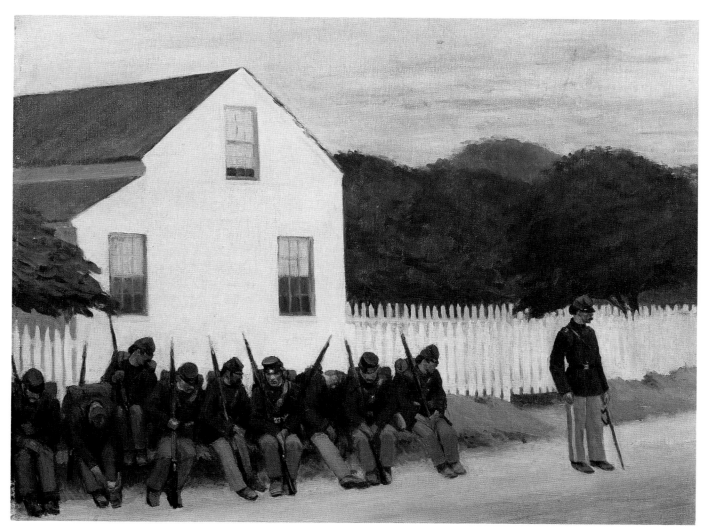

29. *Dawn Before Gettysburg*, 1934. Oil on canvas, 15 × 20″.

CHARLESTON, SOUTH CAROLINA

Charleston, South Carolina enticed the Hoppers to make their first automobile trip outside New England for the whole month of April 1929. No doubt the southern climate offered a respite from still cool New York, but they certainly were attracted by the revival of interest in local history and culture, known as the Charleston Renaissance, which had begun during the 1920s. So many writers and artists flocked to Charleston that in 1928 one northern journalist commented upon the "pilgrims who go that way to worship at the shrine of spring," stressing "the inexhaustible picturesqueness of Charleston," where "on every side an artist set up his easel in devotion."

The Hoppers were both enthusiasts of Henry James, who anticipated themes of nostalgia for the past when he described in *The American Scene* (1907) his 1905 visit to Charleston: "the mere magic of the manner in which a small, scared, starved person of colour, of very light colour, an elderly mulatress . . . just barely held open for me a door through which I felt I might have looked straight and far back into the past. The past, that of the vanquished order, was hanging on there behind her . . ."

Nor can such avid readers as Edward and Jo have missed the reviews of DuBose Heyward's *Porgy*, the 1925 bestselling novel set in Charleston. Whether or not they actually read the book before deciding to make their journey, they did not see the play of the same name until October 9, 1929, after their return, even though the play opened in October 1927. *Porgy* captivated George Gershwin as early as 1926, when he first approached Heyward about collaborating on an opera based on the novel, although the opera *Porgy and Bess* only opened in 1935.

The novel's vision of Charleston and antimodernist reverie held a particular appeal for Hopper, who was especially drawn to the image of local African-American culture. The novel's opening no doubt spoke to Hopper's own longing for the values and culture of the past: "Porgy lived in the Golden Age. Not the Golden Age of a remote and legendary past; nor the chimerical era treasured by every man past middle life, that never existed except in the heart of youth; but an age when men, not yet old, were boys in an ancient, beautiful city that time had forgotten before it destroyed." A little over a year after Hopper's return from Charleston, his close friend, the artist and critic Guy Pène du Bois appropriated from Henry James the phrase, "American

Scene," and applied it to Hopper's nostalgia for the past in architecture and culture:

> It would be well to examine the American scene. There must have been some original difficulty finding it. It is extremely rare. It is composed of relics. Its active life ceased not later than nineteen hundred. Wherever a town has been progressive, and America is said to be progressive, the American scene has been wiped out of it. Two research men, historical painters, are the straws which are going to save our elephant. They are Edward Hopper and Charles Burchfield.

Charleston's importance during the Civil War must also have appealed to Hopper, for he had been fascinated by the lore of those battles since boyhood. Fort Sumter, located on a small man-made island at the entrance to Charleston's harbor and under almost constant bombardment by Union forces from 1863 to 1865, became a symbol for both sides during the conflict. More immediate than his boyhood Civil War sketches, Hopper had painted a watercolor, *Civil War Campground*, in Rockland, Maine, just three years earlier. In Charleston, he made a watercolor of the Battery, with its ancient cannons poised among the palm trees and park benches. He chose to stay within walking distance of this historic site.

The Hoppers boarded at 157 Tradd Street with Frances Wulbern, a widow with three children, one of whom, Gertrude Wulbern Haltiwanger, was then about twenty. She recalled to me that the Hoppers liked their room on the top floor because of the good north light but did not take their meals there, that Edward was not particularly pleased with Charleston, and that he was acquainted with Alfred Hutty (1877–1954), a local artist recognized for his etchings, who lived at 46 Tradd Street, not far from where the Hoppers stayed. Before Hutty settled in Charleston at the close of the First World War, he may have met Hopper through their mutual friend, George Bellows, for the three artists exhibited in the same print circles.

It was from the second story porch at 157 Tradd Street that Hopper painted a watercolor of *Ash's House* (Pl. 32), conveniently located across the way at 158 Tradd Street. He chose a characteristic Charleston house with a veranda, a "single house," the popular local style from the mid-1800s, in which a house the width of a single room was set at right angles to the street to better catch the cool breezes in the hot climate. In the record book she kept, Jo noted: "White shingles, red tiled roof, very brilliant white & sharp shadows. 2nd story, tops of trees from yard below. 2nd floor porch." Hopper's raised vantage point enabled him to look down into the second floor porch of Ash's house. He focused on the strong visual contrasts of light and shadow characteristic of Charleston.

Just a few blocks away from his Tradd Street lodgings, Hopper painted an interior view of an empty

Lutheran Church, an early nineteenth-century building located at 10 Archdale Street. In *Baptistry of Saint John's* (Pl. 31), he recorded the white marble rail and font, black and white tiled floor, and the altar stairs in the background. In an unusual gesture, he made a detailed preparatory sketch of the cloth covering the cross on the baptistry font. Perhaps the exceptional focus on a still life subject prompted this exercise. Hopper, who had long since rejected his own Baptist upbringing, never painted another church interior. Twenty years later, Jo made a telling comment in a letter to the journalist J. Donald Adams: "The inanity of early Sunday School predisposes many of us against churches—unless they are beguiling and empty."

Further away from where he was boarding, but still in the historic district, Hopper singled out an entrance at 56 Society Street, which he called *Charleston Doorway*. In the record book, Jo wrote only: "Charleston Doorway. (& gate posts, small window with shutters at R. [right] Brown & cream colored house 1st story."

Hopper painted other watercolors such as *Charleston Slum* and *Folly Beach*, but these seem to be specific locations that today have changed beyond recognition. Whether Hopper knew that the Heywards lived at Folly Beach is unclear, but he characteristically singled out a dead tree among the shaggy palms. It was also there that he sketched a typical Low Country cabin with a female figure perched in the doorway. About the latter work, he recalled as late as 1956:

> We used to go along Folly beach. I remember you had to pay to get in. Sometimes I'd find a house I liked. There was this cabin in the woods, and I stopped to sketch it. This mulatto girl came out of the cabin and she seemed interested in what I was doing. Then her husband came home. He was drunk or something and he was going to do something, I don't know what. I beat it."

The grip of this experience on Hopper's erotic imagination was so intense that it prompted him to paint the sultry woman of his 1956 canvas, *South Carolina Morning*.

Back in town, Jo, but not Edward, painted a watercolor of 17 Chalmers Street, a local landmark known as the Pink House, which is said to be the oldest tavern building in the South, dating from the mid 1690s. Constructed in Bermuda stone of a pink cast, the house still has its original terra cotta tiled roof. Although this unique structure has attracted many artists, Hopper probably dismissed it as too picturesque. Likewise, when he and Jo drove to Summerville, South Carolina, to visit a well known magnolia garden and stopped on the way to look at an eighteenth-century church in Goose Creek, Hopper preferred to admire the pale pink stucco building rather than paint it.

30. [The Battery, Charleston, S.C.], 1929. Watercolor on paper, 13⅞ × 19¹⁵⁄₁₆″.

31. *Baptistry of St. John's*, 1929. Watercolor on paper, 14 × 20″.

32. *Ash's House*, 1929. Watercolor on paper, $13\frac{7}{8} \times 19\frac{7}{8}''$.

WESTERN UNITED STATES

As a boy growing up along the Hudson River in Nyack, Hopper had plenty of opportunity to become acquainted with the great nineteenth-century paintings of the American West. These heroic images were much reproduced in the illustrated magazines with which the Hopper household was well stocked. The enormous panoramas of western scenery by Albert Bierstadt were particularly celebrated in Nyack, since the painter had lived for a time just across the river in Irvington-on-Hudson.

Yet the dramatic heritage of Western painting played an ambiguous role in Hopper's mature art. In an ironical echo of the tradition, he would depict a painting of a mountain landscape as decoration in *Hotel Lobby* (1943). But when he actually traveled West in search of the inspiration so many others had found there, he was repeatedly disappointed, finding at most fitful occasions in sights and situations very different from those featured in the grand tradition.

By and large, Hopper preferred views more familiar and closer to home in New York City, where he went to art school and struggled to make a career,

and in rural New England, where New York artists liked to summer. Apart from three early trips to Paris, it was only after his marriage in mid-life that he ventured beyond New York and New England. From June through late September, 1925, Hopper

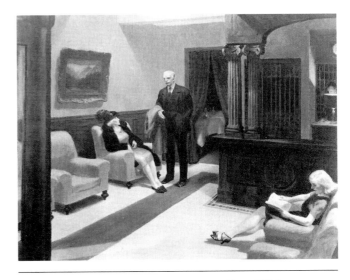

Fig. 16. *Hotel Lobby*, 1943, oil on canvas, 32½ × 40¾″.

113

and his bride of less than a year set out for Santa Fe, New Mexico, traveling by train via Niagara Falls and Chicago.

The Santa Fe Railroad had promoted tourism since the 1890s and, by the mid-1910s, New York artists from Hopper's circle such as Robert Henri and George Bellows had begun to pass their summers in Santa Fe, ignoring the more vanguard crowd in neighboring Taos. John Sloan's enthusiasm for Santa Fe was such that he purchased a house there in 1920. Hopper was also drawn to Santa Fe because he wanted to try "Indian baths" as a cure for his arthritic knee.

As it turned out, Hopper complained of the intense light, saturated colors, and "gaudy mountains" that made the southwest too picturesque for his sensibility. At first he could find nothing he wanted to paint. Unlike Sloan, who drew inspiration from the mesas and mountains around Santa Fe, Hopper found them disappointing, "like sand hills," although he later allowed that "The mountains are better near Albuquerque." To his mother, however, he wrote an illustrated letter of the twenty-five mile horseback ride that he and Jo made through the mountains, commenting: "It being only the fifth time I had ridden I thought much more about the hard saddle than I did of the mountains, but they seemed fine when I could look at them."

The promotional literature of the Santa Fe Railroad and its hotel and restaurant chain, the Fred Harvey Company, emphasized the Indian and Spanish cultures of the Southwest. Indian images and rituals appealed to Sloan, Henri, and many other artists, but not Hopper. He and Jo did attend the Corn Dance at Santo Domingo, but the only Native Americans Hopper ever depicted were costumed models in art school and, years later, some of the people living around Mitla, Mexico, whom he sketched on location.

Fig. 17. From a letter to his mother, July 27, 1925, 8⅞ × 5½".

Fig. 18. *La Penitente*, 1925, watercolor on paper, $19\frac{5}{8} \times 13\frac{1}{2}''$.

Hopper did find the Spanish-American culture more intriguing, perhaps because it evoked for him his visit to Madrid and Toledo in 1910. He was particularly fascinated by the Penitente Order, a secret religious organization of Spanish-Americans, which was notorious for self-flagellation and which dramatized the passion story during Holy Week. The Penitentes may have reminded him of the Spanish mystics shown in paintings by El Greco that he had seen in Toledo. In his watercolor, *La Penitente*, Hopper painted a dark figure of a lone woman in a windy

landscape, although generally he tried to avoid the theatricality of New Mexico.

Discouraged by the raw, primitive quality of Santa Fe, which had not yet acquired street lights or paved roads, Hopper initially chose to paint a more familiar subject: a locomotive from the Denver and Rio Grande Railroad which became the subject of two of the watercolors he painted in New Mexico. Amazingly, this classic steam engine survives today as a part of the narrow gauge Cumbres & Toltec Scenic Railroad that runs from Chama, New Mexico to Antonito, Colorado.

Having painted the railroad, Hopper finally digested the local architecture, discovering some atypical structures to paint: the Cathedral of St. Francis and St. Michael's College. Both buildings offered complex and intricate angles and towers. Despite the rapid growth of Santa Fe, the Cathedral of St. Francis still stands proudly in the town's center, although Hopper's precise vantage point no longer exists, obliterated by changes to the surrounding buildings. St. Michael's College, designed by a French architect brought over by the Christian Brothers, also survives, known today as the Lamy Building. Unfortunately the structure lost its top floor in a fire in 1927, just two years after Hopper painted it.

Before leaving Santa Fe, Hopper also painted more typical adobe houses and desert landscapes, as

116 well as the strong silhouette of the local poplar trees. If any of these specific sites remain intact today, they have been obscured by the rapidly changing face of Santa Fe. Hopper exhibited only seven of his New Mexican watercolors, rejecting almost as many as he found acceptable. Twenty-six years later, when the Hoppers returned to Santa Fe in July 1951, stopping briefly on their return drive from Mexico, they found the town so changed, "so cluttered and mangy," that Jo remarked that it reminded them of Coney Island, the tattered Brooklyn amusement park.

After the 1925 trip, the Hoppers did not venture west again until late May 1941, when they drove their second-hand Buick across the country. If the tradition of Western painting had raised hopes of inspiration, the reality proved problematic. After a week of steady driving, they rested for three days in Colorado Springs, where Edward, perhaps fatigued by both the driving (which he insisted on doing himself) and the effect of high altitude, decided that he was not going to paint the Rocky Mountains. They pushed on to California and to Yosemite National Park, the site of heroic paintings, where Edward complained about "the lack of clearness of atmosphere" and the resulting lack of bright color and sharp lines.

Eager to visit San Francisco but wanting to economize, the Hoppers stayed at a tourist court half an

Fig. 19. *House at San Mateo*, 1941, watercolor on paper, 13¾ × 19½".

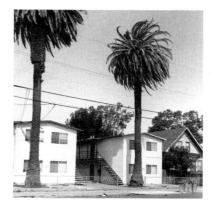

hour from the big city on the Bayside Highway in San Mateo. At last Hopper, who had not resonated to the grand vistas of nature, found a motive to paint. Jo recounted in her diary how he took:

> another look at an old house in San Mateo—with 2 good palm trees & finally decided to do a small watercolor—to my delight that he should make a start out here too. So he sat in the back seat of car—cursing constantly at smaller space in this car . . . I in the front seat had the wheel in my way & nothing to prop up my watercolor paper—but we managed somehow.

Later, Edward recalled: "We stopped at a motel in San Mateo for a week or so, not wishing to stay in San Francisco, although we drove into the city a number of times. I discovered the house on a side street and thought it interesting, so made a watercolor of it while sitting in the car." Faced with uncertain weather, Edward delayed finishing his watercolor until two days later, when, as Jo noted, "he decided to do what he could without sunlight—& after he got started there were glimpses of the sun occasionally." Unfortunately, the old Lawrence house painted by Hopper has been torn down and replaced, but the house next door (visible on the right) and the two palm trees have survived, the latter grown tall with age.

After their meagre results in San Mateo, the Hop-pers pressed northward, stopping to linger only when they reached southern Oregon on June 28. They chose to stay at a cabin on a beach that must have reminded them of their life on Cape Cod and raised hope of finding subjects to paint. Exploring the environs, as Edward often did on the Cape, they came upon the dramatic stretch of coast at Pistol River, which lies some forty miles north of the border with California and ten miles below the considerable town of Gold Beach, and which today has become part of Oregon's Pistol River State Park. The scene at Pistol River impressed Jo, who referred in her diary to "the really swell beach with mammoth rocks in such good composition too." Comparing the massive boulders that loom from the sea to the eroded sandstone formation they had seen in Colorado, she added, "make Garden of the Gods look like cheese." But eager though she was for Edward to paint something, she was not happy with what he produced:

> I don't see that E. has helped himself to a very likely composition. He's just that contrary, he would take something really stunning right under his nose. He's reducing it to a common denominator of any coastal scene. The reality is a picture postcard—what he's doing is any old picture postcard; one you'd especially never touch. I don't get the point. Of course he may do something to it tomorrow—but I can't see

what. And I so want him to get some good pictures. If he makes any fizzle it will set him off trying any more.

As his subject for the watercolor he would call *Oregon Coast* (Pl. 35), Edward chose a long, loaf-shaped isolated massif that bears a resemblance to scenes he had painted in Maine in the late 1910s, when he summered on Monhegan Island. The sand that already in 1941 largely surrounded the rock has now risen into dunes that make it impossible to stand where Hopper stood and get his view. Further altering the scene, the Oregon department of highways has forced through a wide new highway just behind the dunes and close to the rock, which Hopper would have spotted first from the scenic old Coast Highway, a stretch of which still winds its narrow way further back and higher up around the low bluffs above the beach.

Thoughts of New England again emerged when the Hoppers finally reached Portland. Edward allowed that he liked it because it reminded him of Portland, Maine. Even their choice of a place to stay smacks of New England: just outside the city at the Colonial Village campground, something of a rustic motel.

After a brief stay in Portland, they started East, towards the celebrated Yellowstone National Park. Angling down across Oregon, they picked up U.S.

Route 20, one of the great cross-country highways that would lead them back east, which runs right through the park. Jo, who was especially fond of animals, wanted to stop and pet the bears, but Edward refused. She wrote to a friend: "One of the most moving things for me was the sight in Yellow Stone Park of great big mamma bears with young daughters in tow sauntering about the roads, accepting ham sandwiches from tourists—and an elk near by quite undismayed—for this one place where man and beast walk the face of the earth in amity—a step toward the Garden of Eden." Recent incidents of bears attacking tourists suggest that Hopper's reasons for not stopping may have been more protective than uncaring.

From Yellowstone the Hoppers drove a short distance east through the Shoshone Valley National Forest, where they spent a week in a log cabin in the town of Wapiti, some twenty-two miles west of Cody, Wyoming, in the Absaroka Range of the Rocky Mountains. Edward began *Shoshone Cliffs, Wyoming* (Pl. 36), a watercolor "at the base of the Holy City rock formations," located along the Shoshone River, just a few miles west of Wapiti. He chose to work near the river at the bottom of the craggy rock, rather than from his car as was usually his habit. Although the strong light and shadows on the rugged rocky gorge must have appealed to Hopper,

Jo complained about "the fossils of old cars & bones on the beach giving place a weirdness" and that "every afternoon the sky clouded up & all but rained." "Not that it would ever rain & be done with in this country. . . . ," she recalled. "When we got back to Holy City, the sky burned in splendor—but not for long. E. & bath went doggedly on—somehow. E. protected his watercolor during the rain fall—black oilcloth bag—& at it again, partly from memory." She concluded: "I'm so glad it's a fine one—to justify expense of our stay . . ."

Five years later, in July 1946, retreating from a trip to Saltillo, Mexico, the Hoppers revisited northern Wyoming. They stayed ten days at the Square G Ranch, an old guest ranch located just north of Jenny Lake in the Grand Tetons. Even for the Hoppers, the accommodations were primitive, lacking indoor plumbing, and equipped only with kerosene lamps and a wood burning stove like their own house in Truro. They were early to visit the Tetons, before John D. Rockefeller, Jr. donated 34,000 acres of land to the United States Government in 1950 for inclusion in Grand Teton National Park. Inspired by the majestic landscape, Hopper painted watercolors: *Mount Moran* (Pl. 37), *Slopes of the Grand Tetons*, and *Jo in Wyoming* (Fig. 20).

In painting Mt. Moran, Hopper overcame his earlier diffidence and difficulty with the heritage of Western painting. The mountain had been named in 1872 by the United States Geological Survey to honor the artist Thomas Moran (1837–1926), whose paintings of Yellowstone and the Teton Mountains were instrumental in making Yellowstone a national park. Hopper's style in painting *Mount Moran* reveals an attitude that is more matter-of-fact than Moran's more emotional response and sublime coloristic effects with a tone reminiscent of the English romantic J. M. W. Turner. From a vantage point located near the north side of Jenny Lake, Hopper captured the patches of snow that even in July remain on the lofty peak.

Hopper also marked his distance from Moran's heroic vision in the way he conceived of *Jo in Wyoming*. By locating his own vantage point in the backseat of his Buick, Hopper depicts himself as a thoroughly modern painter, using his car as a mobile studio. Although his 1925 trip had preceded his acquisition of a car by two years, his later excursions across the Mississippi were all with himself at the wheel. The fact that he also represents his wife painting her picture of the Grand Tetons in the front seat documents the demands that marriage to a thoroughly modern woman and fellow artist made on Hopper.

Hopper's last trip West resulted from an invitation from the Huntington Hartford Foundation in

Fig. 20. *Jo in Wyoming*, 1946, watercolor on paper, 13⅝₁₆ × 20″.

Pacific Palisades, California. After their drive across country, Jo had convinced Edward "to stop off for breathing spell." They arrived on the ninth of December, 1956, and, pleased by what they found, stayed six months. Prepared meals, comfortable accommodations, and plenty of company for Jo should have meant ideal conditions for Hopper.

By February 18, he wrote to his dealer and admitted "I've not done much considering the length of time we've been here: just an unfinished watercolor, but I hope to start a canvas soon." *California Hills* (Pl. 38), the only watercolor that Hopper painted at the Foundation, depicts a tall green hill with a sand bank at the ridge of a road on the right. On the other side of the composition is a "building of modern design," which Hopper said was a corner of one of the studios. He did not complete the sky in his watercolor until the following summer on the Cape because, as Jo reported in her diary, "a most aggressive female," discovering that he had been on the cover of *Time*, "determined the hours when & where E. was working [outdoors] & descended on him—not withstanding the basic assurance that work was sacred & no intrusions to be tolerated."

By March 22, Hopper vacillated whether to stay on in California, but soon surrendered to the comfortable life at the foundation. Jo noted in her diary that Hopper disliked driving in the Los Angeles traffic to such an extent that he preferred to remain "in the Canyon at Pacific Palisades, altho completely unimpressed by the rich green depths." Responding in a minimal way to the new visual stimuli, Hopper was quoted in *Time*: "The Pacific Ocean is sort of misty, grayish." Jo later reported: "E. did one sizable canvas & one watercolor & read thru the nice library the rest of the time & enjoyed our neighbors, the birds, so tame, the charming deer & raccoons."

At the end of April, Hopper reported to his dealer: "Not much painting for me here this winter, but I have one good canvas 30 × 50, and an unfinished

Fig. 21. *Western Motel*, 1957, oil on canvas, 30 × 50″.

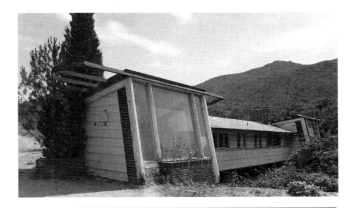

Fig. 22. Lloyd Wright studio-residence, Huntington Hartford Foundation, 1973.

water color." The canvas, painted in late February or March, was called *Western Motel*. In the record book, Jo, who recalled incorrectly that Edward had painted it in January or February, described the subject as a "Deluxe green motel room, mahogany bed, pink cover, dark red chair with blue robe." The female figure was a "Haughty blond in dark red, her Buick outside window green." In her diary, Jo described the painting, "with its front, that glass front of our fine Lloyd Wright guest house."

Thus both the watercolor and the canvas record the modern architecture at the foundation, which was established in 1948. Lloyd Wright, the son of the famous architect, designed the new studio-residences with large picture windows featuring views of the landscape of Rustic Canyon. Although these buildings no longer exist, having been destroyed by a fire, the surrounding landscape remains essentially the same.

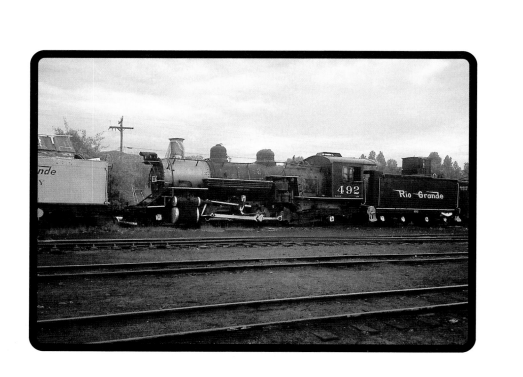

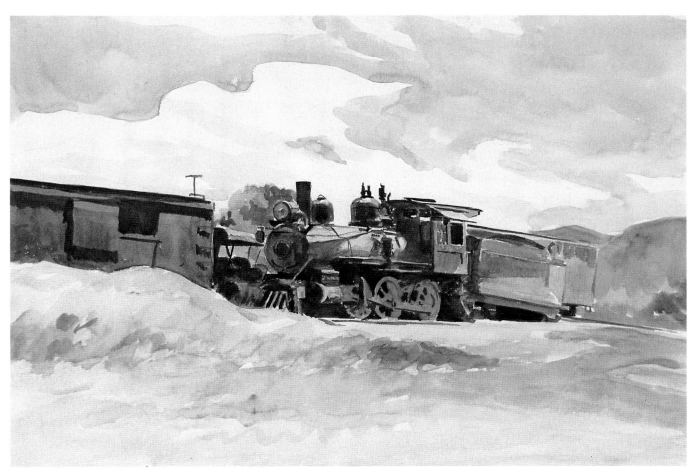

33. [Locomotive and Freight Car], 1925. Watercolor on paper, 13⅞ × 19¹⁵⁄₁₆″.

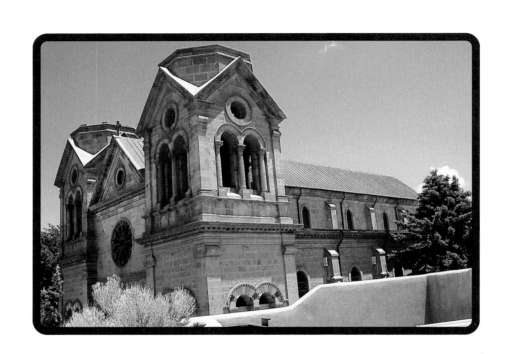

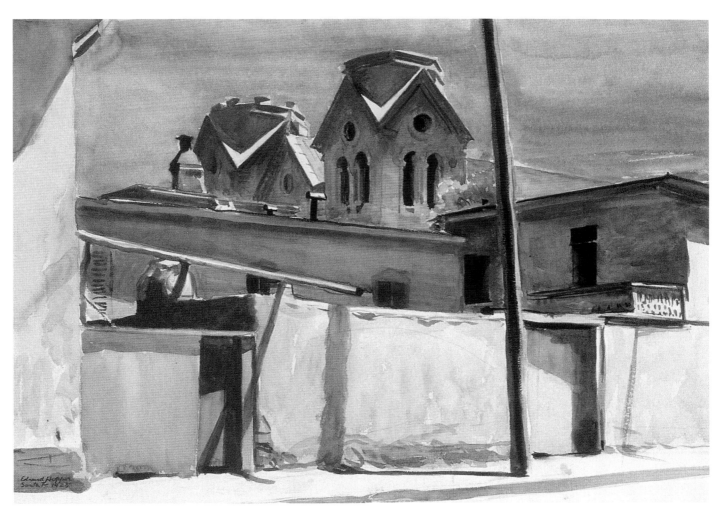

34. *St. Francis Towers,* 1925. Watercolor on paper, $13\frac{1}{2} \times 19\frac{1}{2}''$.

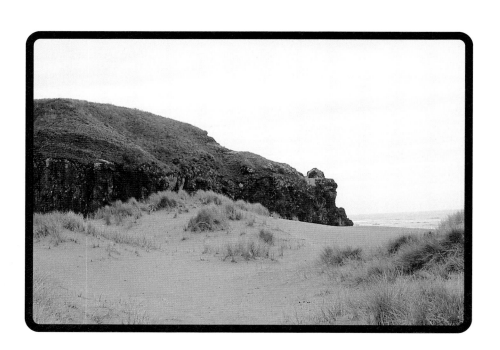

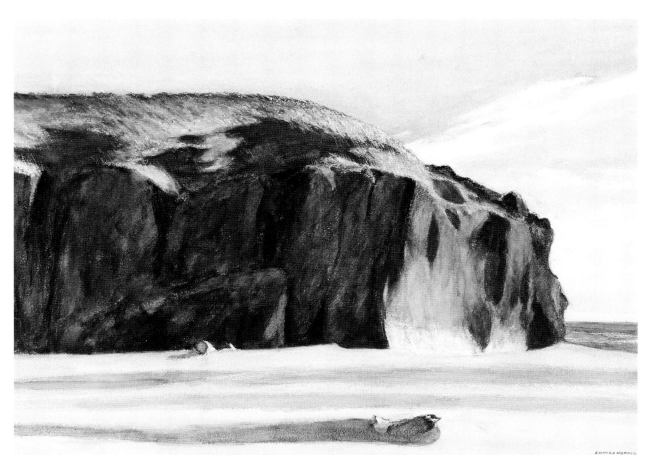

35. *Oregon Coast*, 1941. Watercolor on paper, 20 × 28″.

36. *Shoshone Cliffs, Wyoming,* 1941. Watercolor on paper, 20 × 25″.

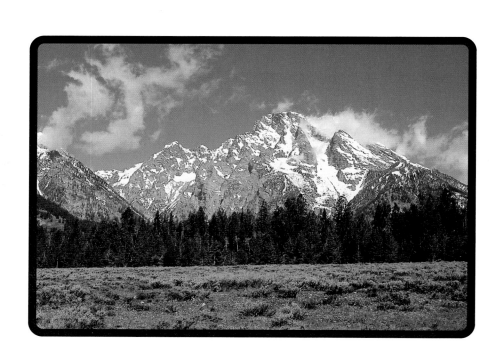

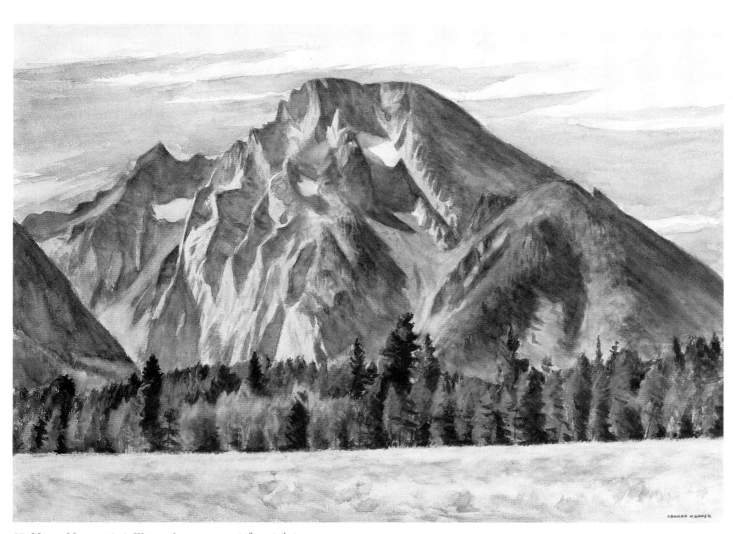

37. *Mount Moran*, 1946. Watercolor on paper, 20¾ × 28½″.

38. *California Hills,* 1957. Watercolor on paper, 21½ × 29¼″.

MEXICO

Mexico first attracted the Hoppers during the Second World War, when gas rationing kept them from driving to Cape Cod, where life in their isolated summer cottage would have required still more fuel. The trip to Mexico would be by train. Hopper justified it with the hope he could "do some painting there," explaining, "my conscience troubles me somewhat about skipping away in this manner, but I have to keep on with my work and there will be more freedom of movement in Mexico than there will be here just now." Putting aside patriotic qualms, the Hoppers departed on June 29, 1943, arriving in Mexico City on July 3, where they had reservations at the Ritz Hotel. Unlike most of the American artists who had preceded them, Hopper felt attraction for neither the spectacular landscape nor the distinct culture and politics.

Exploring the Mexican capital and its environs busied the Hoppers for nearly two weeks, but Edward found nothing to paint and became restless. Not that circumstances proved ideal elsewhere, as Edward wrote to his dealer, Frank Rehn: "We left Mexico City toward the end of July and have been in Saltillo ever since. It has a nice climate and is among some interesting hills. It is pretty hard to get near them or do much of anything without a car, but I have made a few watercolors, nevertheless." Jo concurred for a different reason: "It's much too hot to try to paint out. One should never come to Mexico without a car." In moving to Saltillo, a small textile-manufacturing city located over five hundred miles to the north, they had sought out a cooler, quieter, cheaper setting in which to paint. In this city famous for its finely woven serapes, they stayed in a private home, the Guarhado house, at Victoria 404, but took their meals at the nearby hotel, the Arizpe Sainz.

From the roof of the house where they were staying, Edward painted four watercolors. Jo explained in one of her own letters to Rehn why Edward had decided to work on the roof: "Among mts. doesn't mean you see any of them. They surround the place but there are always walls or towers or electric signs even, to shut out the view. E. sits out on our one story roof that affords more roofs & snips of things neither distinguished nor readily distinguishable & feeds upon that." She repeated their earlier complaint about lack of mobility: "It hasn't been easy to

135

do anything without a car. Can't perch out in a blazing sun surrounded by young buzzards. The roof so far has yielded 2 watercolors finished & 2 on the way. It rains every afternoon at varying hours, so that slows up productions."

In *Palms at Saltillo*, Hopper depicted a view of the pale adobe roof surface with trees and other buildings visible in the distance. [Roofs, Saltillo] (Pl. 41), painted in late July, is a vista looking off in different direction, featuring rooftops against a backdrop of beautiful blue-green mountains. The chimney pots and pipes in the foreground are reminiscent of Hopper's prospects from the roof of his studio on Washington Square, suggesting that he sought something familiar in the midst of such a foreign setting. In August, Hopper painted two additional views from the same roof: *Sierra Madre at Saltillo*, with rooftops and a utility pole before the majestic mountain landscape, and *Saltillo Mansion*, a picture of a nearby house with an elaborate cornice and decorative trim seen against the mountains.

According to Jo, Edward was "crazy about the mts. we passed on R.R. on way up to Mexico City— mts. around about Monterey [sic]. But he heard Monterey was hot so came here instead, 50 miles south of Monterey but high elevation so cool. People from Monterey & state of Texas swarm here." She lamented: "He didn't bring any canvas or oil paints which is calamitous, because if it cools off enough to go to Monterey for 3 weeks in Sept. there is one gorgeous view from a hotel room window that I've unearthed & it's a crime not to do a sizable canvas of those mts. right out of window." It seems that Edward had determined that he preferred to work in watercolor in Mexico. He had written to Rehn:

We may go to Monterrey, near here about the first of September, as there are fine rugged mountains very near the city, that could be painted from some of the hotels there. The drawback is the terrific heat in Monterrey (about 1500 feet altitude) while Saltillo is very cool at night, and has a dry heat during the day. However I shall make an effort to get something at Monterrey, when and if it gets cooler.

On September 1, the Hoppers left Saltillo for Monterrey. Jo was pleased with herself that she had located a hotel room with the view and booked a reservation. Once settled, she happily reported in another letter to Rehn: "He sits at the window of our room at this hotel & with the greatest of ease gazes out. . . . It's blistering hot, this town, a little better in Sept., but he has a fine big electric fan on the ceiling over his head & after 3 days hounding the office we have the window screens removed so we can actually see out."

Hopper did produce two watercolors out of that hotel window: *Sierra Madre at Monterrey* and *Mon-*

terrey Cathedral (Pl. 39). In the former, he focused on the splendid shapes of the mountains, keeping roof tops to the lower portion of his composition, while in the latter, he once again featured rooftops, along with the strong ornate shapes of the Baroque cathedral with its dramatic mountain backdrop. He chose to include both a palm tree and a sign for a hotel poking out over the rooftops. The work came to a halt at the end of the month, when the Hoppers' excursion train ticket made them return to New York.

Not quite three years later, in May 1946, the Hoppers departed on their second trip to Mexico, once again heading for Saltillo. This time remembering their previous frustrations, they went by car. The Arizpe Sainz Hotel, where they had taken meals on their previous visit, now became their lodging. Their room opened onto a roof from which they could paint. Despite suffering in a heat wave, Edward began work on a watercolor of roof tops, working after five when the sunlight shifted to their building. From the same perch, he also painted three other watercolors: the *Church of San Esteban* (Pl. 40) depicting an old mission church dating from 1592, a view with the movie house *El Palacio* (Pl. 41), and *Construction in Mexico*. The regularity of late afternoon showers made it difficult for him to finish these works. Hopper said he felt like a prisoner in Saltillo,

where he was obliged to wait for blue skies in the right light in order to complete his watercolors. He was particularly glum, complaining that he just did not like the people, the architecture, or the climate. On July 2, he and Jo left Saltillo, heading northwest through Texas and Colorado.

Five years later, in late May 1951, still driving the 1939 Buick that had served their previous trip, the Hoppers set out once more for Mexico. Minor automobile accidents cost them five days for car repairs, postponing their arrival in Saltillo until the tenth of June. About two years later, Hopper explained to his friend Guy Pène du Bois why he and Jo repeatedly returned to Mexico but did not visit him in France:

> I agree with you about the beauty of the buildings in France and one certainly sees nothing as impressive in Mexico. The great cathedral in Mexico City can not stack up with Notre Dame de Paris, or Chartres, or any of the others, but if you put a certain limited interpretation on the two civilizations, there is perhaps not so much to choose from. Of course the Aztecs did cut the hearts out of their victims but then there was that horrible massacre of Saint Bartholomew's Eve and The Terror of 1793, when so many heads were lopped off. However I think that France has quite an edge on Mexico even so.

The thing is that to get to Mexico all you have to do is put your luggage in your car at the door and drive until you get there—as easy as that! Getting

Fig. 23. *Cliffs near Mitla, Oaxaca*, 1953, watercolor on paper, 20½ × 28¼″.

Fig. 24. *Mountains at Guanajuato*, 1953–54, watercolor on paper, 22⅝ × 30⅝″.

back into the States is somewhat more bothersome because of the U.S. Customs, but one can put up with it and one does not get seasick on the way.

In Saltillo, the Hoppers returned to the same hotel and their old room with its familiar views. An unusual hot spell, problems adjusting to the high elevation and the local food, and then sudden rainy and windy weather prevented Hopper from completing any work. Jo had to stop painting her own canvas of the hotel's patio when Edward "got fed up

with Mexico" and abruptly decided that having been there a month they should leave at once.

Undeterred, they went back in December of the next year, but this time to a different place, Guanajuato, which Edward described as "a fine old city, but very much on the picturesque side." He admitted to Rehn: "We hate to leave to go further south because of the good food and comfort here," reporting sardonically: "The same Mexico as before, peons on burros, dirty markets, poverty and narrow crowded

streets." Despite disdain, he began painting a view of the mountain tops with a little turret surrounded by foliage in the foreground.

Jo grew restless in Guanajuato, but she reported that Edward was "afraid to drive—who wouldn't in this jungle of sharp curves & deep drops . . ." Then they heard about a special place to stay run by Americans interested in anthropology far to the South in Mitla. Hoping that the weather would be warmer, the Hoppers headed south before Edward had painted his sky. He later described the ride as "all mountains from Mexico City through Puebla" and "not a drive I would care to take again. It keeps one busy thinking of the edge of the road and rounding the curves."

In Mitla, Edward produced a number of uncharacteristic sketches of Indians, for once revealing some interest in the local people. Finding nothing he wanted to paint, Edward sat on the patio, bored, reading old *Reader's Digests*. Finally, while on a ride in their car, Jo got him to pull over and start a watercolor from a lower road overlooking a stony cliff. With Jo attempting to work in the front seat, Edward in the back sketched his composition for *Cliffs Near Mitla, Oaxaca*. The next day, he wrote to Frank Rehn about his progress: "We have moved here to the south of Mexico, in an effort to get warm. The nights are still cold here but the days are hot. I did a watercolor in the last place that we stayed (Guanajuato) but I don't think much of it. I've started another which promises to be better." That day, he began to add color to his sketch which Jo said made him "more content." As they headed home, Jo summed up their sojourn in a letter, complaining that Edward, who lacked ambition, had "turned Mexican, content to loll in patios with uneasy conscience."

In spite of the difficulties and complaints, the Hoppers in the spring of 1955 ventured one last Mexican trip. Arriving in Monterrey, they spent twenty-three days at a motel just outside of the town itself. Feeling weak and tired, Hopper did not paint. With Jo behind the wheel on part of their return trip, Edward became so annoyed that he tried to find a traffic cop to force her to stop driving. Anxiety over ill health and their constant dispute over Jo's desire to drive precluded returning south of the border ever again.

39. *Monterrey Cathedral*, 1943. Watercolor on paper, 21 × 29″.

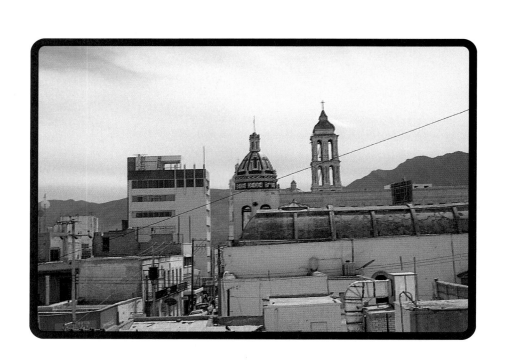

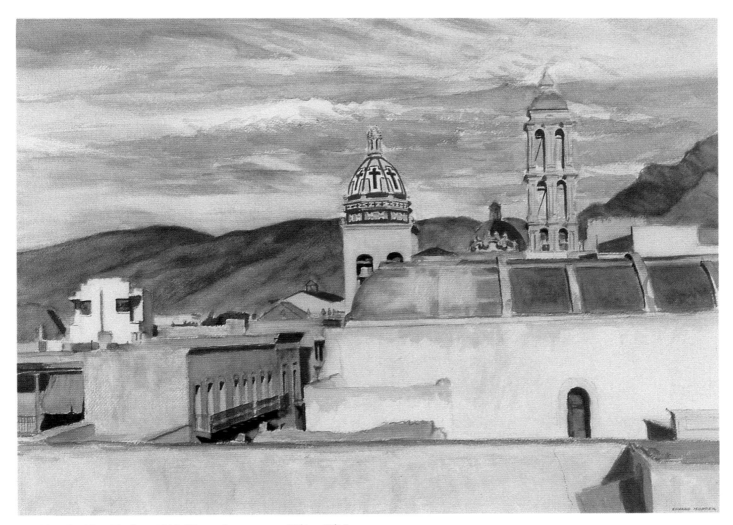

40. *Church of San Esteban*, 1946. Watercolor on paper, 22¼ × 30½″.

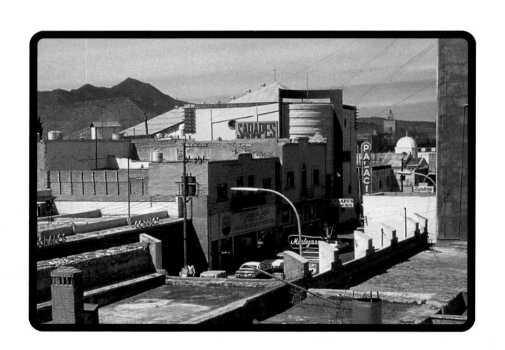

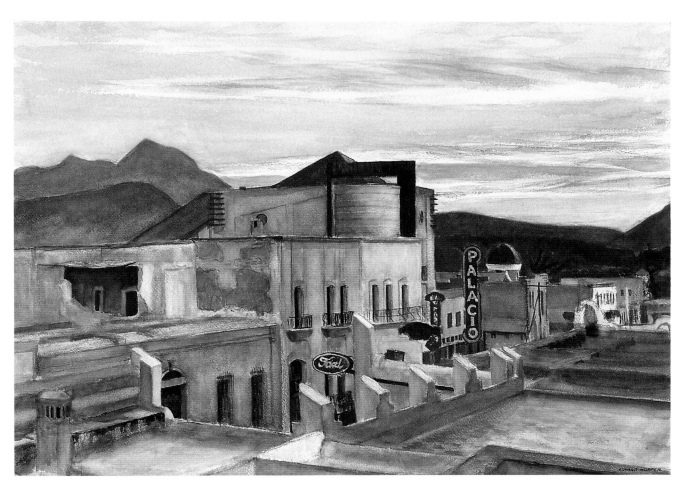

41. *El Palacio*, 1946. Watercolor on paper, 22¼ × 30¾″.

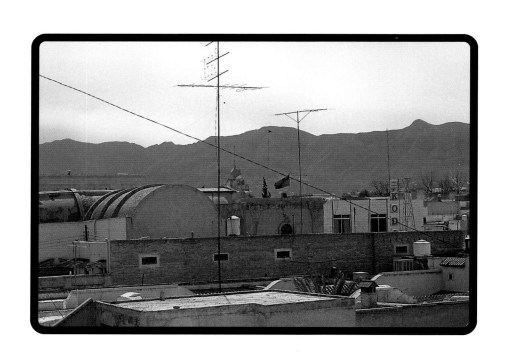

42. [Roofs, Saltillo], 1946. Watercolor on paper, $22\frac{7}{8} \times 30\frac{5}{8}''$.

PARIS, FRANCE

Hopper first traveled to Paris in the autumn of 1906, aged 24, having just finished art school the previous spring. Through his family's church, he arranged to board with a widow and her two teenaged sons in rooms at the top of the Baptist mission in Paris—the *Eglise Evangelique Baptiste*—located at 48, rue de Lille, on the infamous left bank of the river Seine not far from the Bohemian Latin Quarter.

In letters written to his family back home, Hopper described his first impressions: "Paris is a very graceful and beautiful city, almost too formal and sweet after the raw disorder of New York. Everything seems to have been planned with the purpose of forming a most harmonious whole which has certainly been done. Not even one jarring note of color is there to break the dismal tone of the house front, which is a universal grey or buff."

About a month into his stay, Hopper reported: "I have been painting out-of-doors and do not need a studio as yet. The weather has been very mild and would be pleasant were it not for the rain which comes down at the most unexpected moments, even out of a clear sky." He soon learned that rain would limit work outside. The weather, as much as his training, affected his initially somber palette. It was a wet and cool autumn, even for Paris. He adapted to the environment by painting small panels at home on the rue de Lille: the interior staircase leading to the apartment where he boarded, a view across a balcony railing of windows and a Mansard roof (a shape made familiar by Nyack houses built in the American version of Second Empire style), and the corner of an interior courtyard.

Although Hopper faithfully rendered the courtyard's structure, even to the pipe in the corner, he had already begun to eliminate unnecessary detail from his recording of reality. He saw no need to delineate every cobblestone, yet he carefully caught the sloping angles along the pavement's periphery and paid close attention to play of light and shadow.

From the rue de Lille, he soon branched out to the near neighborhood, turning the corner into rue de Bac and walking the block to the Seine, where he painted the embankments with bridges and stairways, a sculpture on a pedestal seen before a corner of the Louvre, and a street scene. The latter, rendered in a simple but dramatic blue-gray tonality

Fig. 25. Edward Hopper in Paris, 1907.

reflects the impression of his new surroundings that he described in a letter home:

> Paris as you must know is a most paintable city ... the streets are very old and narrow and many of the houses slope back from the top of the first story which gives them a most imposing and solid appearance.... The roofs are all of the Mansard type and either of grey slate or zinc. On a day that's overcast, this same blue-grey permeates everything. It's at the end of the streets, and the open windows of the houses in the trees, and under the arches of the bridges.

As the winter months passed, Hopper's enthusiasm increased with the hours of daylight. "I do not believe there is another city on earth so beautiful as Paris, nor another people with such an appreciation of the beautiful as the French," he wrote to his family back home.

Spring offered a new world of possibilities. The cold, wet winter made the new season seem especially glorious, the sunlight incredible; he later recalled: "The light was different from anything I had known. The shadows were luminous, more reflected light. Even under the bridges, there was a certain luminosity." In his estimate Paris was: "the apex of everything. I liked the physical aspect of the city. I worked by myself in the streets, along the river, painting under the influence of Impressionism, painting everything in a high key for nearly a year. It was

probably not a strong, lasting influence, after all. Other than to lighten tones for me. [Robert] Henri's students painted very dark."

Hopper was able to study Impressionist paintings in the galleries and Salons, and in the Caillebotte Collection at the Luxembourg. Not only did the pastel tonalities of Renoir, Sisley, and Monet motivate him to lighten his own palette, but under the influence of their work, he also painted with shorter, more broken brushstrokes, a technique apparent in some of his works of 1907 such as *Tugboat at Boulevard Saint Michel* and *Le Louvre et la Seine*. That year, he produced a number of light-hued paintings with pink, blues, lavenders, and yellows predominant, including *Après midi de Juin* (Fig. 26), and *Pont du Carrousel in the Fog*, and *Le Pont des Arts* (Pl. 44). Hopper often set up his easel along the Seine and delighted in being able to work outdoors. "Paris is very beautiful in the sun," he exclaimed, adding: "the people never miss a clear day to be out in the street and the parks."

Beyond the work of the Impressionists, Hopper appears to have taken an interest in the work of Albert Marquet, whose work he must have discovered when he visited the Autumn Salon of 1906. Marquet, who followed with a one-man exhibition at the Galerie Druet in February 1907, had painted several of the sites that Hopper would himself depict in the next few months, including *Notre-Dame*, *Quai des Grands-Augustins*, *Quai du Louvre*, and *Pont Neuf, temps de pluie*. Hopper seems to have switched back to a more subdued palette and to have taken a prosaic simplified approach to his subjects, resembling Marquet's ordinary, non-dramatic views of Paris. For example, in Hopper's two canvases of *Notre Dame de Paris*, he captured the forms of this celebrated Gothic cathedral, but managed to simplify the details, preferring more solid planes of quiet colors. Like Marquet, Hopper also adopted a style of summarizing the human figure with a quick brushstroke, as can be seen in *Le Pont des Arts* of 1907, which he painted from the beneath the bridge with the Pavillon de Flore of the Louvre visible in the distance.

Hopper also investigated photography while he was in Paris. Years later he admitted that he had once bought a camera and taken pictures of architectural details but lamented "the camera sees things from a different angle, not like the eye." He was amazed "by how much personality a good photographer can get into a picture." He later admitted that he admired the photography of Eugène Atget, who was then producing the work he later supplied to artists looking for subject matter for paintings, among them Man Ray, Dunoyer de Ségonzac, and André Derain.

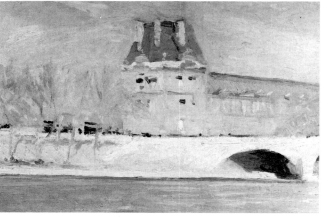

Fig. 26. *Après midi de Juin,* 1907, oil on canvas, 23½ × 28½".

Hopper must have appreciated Atget's melancholy mood and tendency to convey a feeling of solitude. As Atget had, Hopper depicted an interior stairway, left bank streets, and bridges along the Seine. He even took the boat to nearby Saint-Cloud, where his painting of the staircase in the park suggests why he admired the photographs Atget made there. Both artists emphasized the sloping terrain and the rhythmic angularity of the architectural forms. Hopper, however, chose to compress this space through the use of a characteristically flattened perspective.

Paris, and especially the neighborhood of the rue de Lille, stayed with Hopper and became a place of imagination: "I could just go a few steps and I'd see the Louvre across the river. From the corner of the Rues de Bac and Lille, you could see Sacre-Coeur. It hung like a great vision in the air above the city." Another time, the vision appeared to him "hanging like a mirage in the sky as I turned the corner from the Rue de Lille and looked up the Rue du Bac across the river toward Montmartre."

From the time he returned to New York in August 1907, Hopper was determined to get to Paris again. In March of 1909, he arrived there for his second stay, which was to last four and a half months. Despite the death of his former landlady, he eventually

managed to move back in at the rue de Lille. Comfortable in familiar surroundings, he wrote his father, praising "the splendid weather," and taking delight that "the boulevards and parks are looking fine, and the men are wearing straw hats." He painted out-of-doors along the river almost every day. As a result his paintings differ little in theme from those of the previous trip: *Le Pavillon de Flore* of the Louvre and, hard by, *Le Pont Royal* (Pl. 45). His style did evolve to a degree: he utilized much more dramatically the contrast of light and shadow; he completely abandoned the high-key pastels of his earlier canvases. Gradually he freed himself from the impact of the Impressionists: his brushstrokes were no longer as choppy.

Hopper was to travel to Paris only one more time, in May 1910. He stayed there only a week or so, since his long postponed wish to see Spain prevailed over his desire to produce more Paris canvases. After Spain, he spent scarcely three weeks in Paris before sailing for New York. The third venture across the ocean had been the shortest, less than two months all told, and the least productive, resulting in no new paintings. Whatever Hopper had hoped to recapture or acquire did not materialize. Although he never tried Europe again, he admitted: "It seemed awfully crude and raw here when I got back. It took me ten years to get over Europe." On another occasion he sounded more ambivalent: "The life over there is entirely different from the life here. In Europe life is ordered; here it is disordered. And, with the exception of Spain, the light there is different. Those countries don't have the clear skies and sunlight we have here."

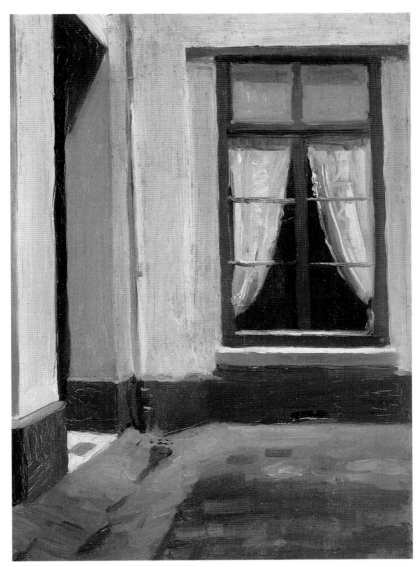

43. [Interior Courtyard at 48 rue de Lille, Paris], 1906. Oil on wood, 13 × 9⅝″.

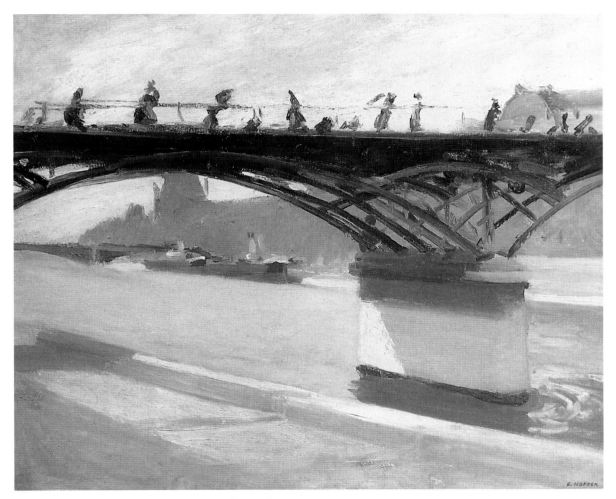

44. *Le Pont des Arts*, 1907. Oil on canvas, $23\frac{1}{16} \times 28\frac{1}{16}''$.

45. *Notre Dame de Paris*, 1907. Oil on canvas, $23\frac{1}{2} \times 28\frac{1}{2}''$.

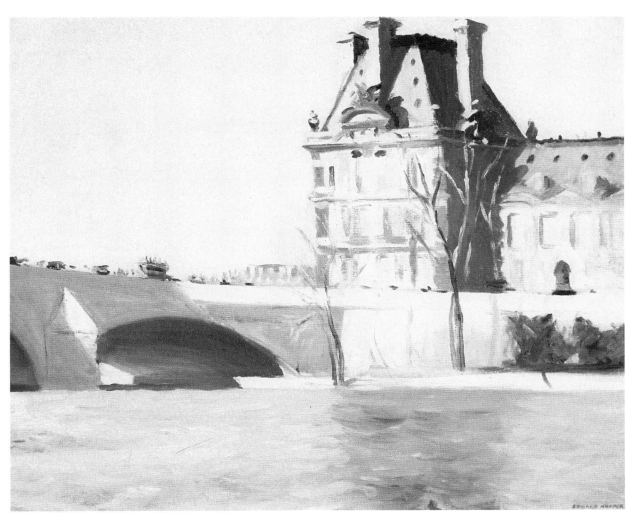

46. *Le Pont Royal*, 1909. Oil on canvas, 23¼ × 28½″.

Brackets indicate descriptive titles given by the author to previously untitled works.

Pl. 1. *City Roofs*, collection of Mr. and Mrs. Mo Ostin; photograph courtesy of Kennedy Galleries, Inc., New York.

Pl. 2. *East Wind Over Weehawken*, Pennsylvania Academy of Fine Arts, Philadelphia; Collections Fund Purchase.

Pl. 3. *Shakespeare at Dusk*, private collection.

Pl. 4. *Macomb's Dam Bridge*, The Brooklyn Museum of Art, New York; bequest of Miss Mary T. Cockcroft.

Pl. 5. *Approaching a City*, The Phillips Collection, Washington, D.C.

Pl. 6. [Stairway], Whitney Museum of American Art, New York; Josephine N. Hopper Bequest.

Pl. 7. *Monhegan Lighthouse*, private collection; photography courtesy of Kennedy Galleries, Inc., New York.

Pl. 8. *Talbot's House*, private collection.

Pl. 9. *Lighthouse Hill*, Dallas Museum of Fine Art; gift of Mr. and Mrs. Maurice Purnell.

Pl. 10. *Captain Upton's House*, private collection.

Pl. 11. *Portland Head-Light*, Museum of Fine Arts, Boston; bequest of John T. Spaulding.

Pl. 12. *Captain Strout's House*, Wadsworth Atheneum, Hartford, CT; Ella Gallup Sumner and Mary Catlin Sumner Collection.

Pl. 13. *Custom House, Portland*, Wadsworth Atheneum, Hartford, CT; gift of Robert W. Huntington.

Pl. 14. *Libby House*, The Fogg Art Museum, Harvard University, Cambridge, MA.; purchase, Louise E. Bettens Fund.

Pl. 15. *The Mansard Roof*, The Brooklyn Museum of Art, New York; Museum Collection Fund.

Pl. 16. *Gloucester Street*, private collection; photograph by Kevin Clarke.

Pl. 17. *Anderson's House*, Museum of Fine Arts, Boston; bequest of John T. Spaulding.

Pl. 18. *Davis House*, collection of Harriet and Mortimer Spiller.

Pl. 19. *House on Middle Street*, Currier Gallery of Art, Manchester, NH; gift of The Friends of the Currier Gallery of Art

Pl. 20. *Prospect Street, Gloucester;* collection of Barbaralee Diamonstein and Carl Spielvogel.

Pl. 21. *Adam's House*, Wichita Art Museum, Kansas; Roland P. Murdock Collection.

Pl. 22. *Rich's House*, private collection.

Pl. 23. *Jenness House Looking North*, John and Mable Ringling Museum of Art, Sarasota, FL; photograph courtesy of Kennedy Galleries, Inc., New York.

Pl. 24. *Near the Back Shore*, private collection.

Pl. 25. *Mouth of Pamet River—Fall Tide*, private collection; photograph courtesy of Wunderlich & Co., Inc., New York.

Pl. 26. *Cottages at North Truro*, collection of Mr. and Mrs. Barney A. Ebsworth.

Pl. 27. *Rooms for Tourists*, Yale University Art Gallery, New Haven, CT; bequest of Stephen Carlton Clark, B.A. 1903.

Pl. 28. *Rooms by the Sea*, Yale University Art Gallery, New Haven, CT; bequest of Stephen Carlton Clark, B.A. 1903.

Pl. 29. *Dawn Before Gettysburg*, The Warner Collection of Gulf States Paper Corp., Tuscaloosa, AL.

Pl. 30. [The Battery, Charleston, S.C.], Whitney Museum of American Art, New York; Josephine N. Hopper Bequest.

Pl. 31. *Baptistry of St. John's*, Greenville County Museum of Art; museum purchase with funds from 1997 Antiques Show.

Pl. 32. *Ash's House*, Museum of Modern Art, New York; The William S. Paley Collection.

Pl. 33. [Locomotive and Freight Car], Whitney Museum of American Art, New York; Josephine N. Hopper Bequest.

Pl. 34. *St. Francis Towers,* The Phillips Collection, Washington D.C.

Pl. 35. *Oregon Coast,* collection of Steven Oifer; photograph courtesy of Sotheby's, New York.

Pl. 36. *Shoshone Cliffs, Wyoming,* The Butler Institute of American Art, Youngstown, OH; gift of Eugene D. Hopper.

Pl. 37. *Mount Moran*, The FORBES Magazine Collection, New York.

Pl. 38. *California Hills*, Hallmark Fine Art Collection, Hallmark Cards, Inc., Kansas City, MO.

Pl. 39. *Monterrey Cathedral*, Philadelphia Museum of Art; gift of Dr. and Mrs. Gustave E. Landt.

Pl. 40. *Church of San Esteban*, The Metropolitan Museum of Art, New York; George A. Hearne Fund.

Pl. 41. *El Palacio*, Whitney Museum of American Art, New York; Josephine N. Hopper Bequest.

Pl. 42. [Roofs, Saltillo], Whitney Museum of American Art, New York; Josephine N. Hopper Bequest.

Pl. 43. [Interior Courtyard at 48 rue de Lille, Paris] Whitney Museum of American Art, New York; Josephine N. Hopper Bequest.

Pl. 44. *Le Pont des Arts*, Whitney Museum of American Art, New York; Josephine N. Hopper Bequest.

Pl. 45. *Notre Dame de Paris*, Whitney Museum of American Art, New York; Josephine N. Hopper Bequest.

Pl. 46. *Le Pont Royal*, Whitney Museum of American Art, New York; Josephine N. Hopper Bequest.

Fig. a. *Skyline near Washington Square*, Munson-Williams-Proctor Institute, Utica, NY; Edward W. Root Bequest.

Fig. b. *The Lee Shore*, private collection.

Fig. c. House in Nyack.

Fig. d. Hopper house, South Truro.

Fig. e. *Bass Fishing at Macomb's Dam, Harlem River, N.Y.*, lithograph by F. F. Palmer; photograph courtesy of The Old Print Shop, Inc., New York.

Among the many people who have helped me to produce this book, the artist Ellen K. Levy deserves my deepest gratitude both for her continuing encouragement of my work as a photographer and for her invaluable insights on painting. My knowledge of Hopper owes a debt to the pioneering work of the late Lloyd Goodrich, who generously shared with me his recollections and expertise and the record books bequeathed to him by Hopper's widow. I have also benefited from discussions with many other friends and colleagues, particularly Greta Berman, the late David Bourdon, and the late Raphael Soyer.

On location, longtime Cape Cod residents Joan Lebold Cohen and Diana Worthington provided important assistance; in Gloucester, Nancy Miller helped me in my search, as did the local firemen. In Maine, Judy Tick generously aided my quest. I appreciate the generous help of photographer Kevin Clarke.

Without the extraordinary contributions of my editor Charlene Woodcock this expanded edition would never have met its deadline. Her enthusiasm and good cheer were matched only by her determination to pin down Hopper's California sites, which she managed in a fashion that was truly collaborative. Thanks to Betty Lou Young and Randy Young, the site of *California Hills* both before and after the fire can be included. The second edition has benefitted greatly from the expert work of Star Type, Berkeley.

In Charleston, I was most recently aided by the generous efforts of Frank and Tami McCann. Earlier in my research, Martha R. Severens, now the curator at the Greenville County Museum of Art, provided important help. On Cape Cod, Anton and Joan Schiffenhaus offered hospitality and invaluable encouragement. Charley and Chardel Blaine, together with Al Schroder, helped me locate *Oregon Coast*. Closer to home, two supportive and insightful friends, the artist Hope Sandrow and photographer Ulf Skogsberg, offered important advice.

Last but not least, my husband John Babcock Van Sickle has, as always, offered editorial advice with affection and acumen. He has shared in these research expeditions, unsparingly devoting himself to my work when he might have been doing his own.

Gail Levin is an art historian and photographer. While curator of the Hopper Collection at the Whitney Museum of American Art she organized exhibitions that laid the foundation for all subsequent study of the artist. Among her books are *Synchromism and American Color Abstraction, 1910–1925; Abstract Expressionism: The Formative Years; Edward Hopper: The Complete Prints; Edward Hopper as Illustrator; Edward Hopper: The Art and the Artist; Marsden Hartley in Bavaria; Twentieth-Century American Painting, the Thyssen-Bornemisza Collection; Theme and Improvisation: Kandinsky and the American Avant-garde;* as well as the definitive *Edward Hopper: An Intimate Biography* and *Edward Hopper: A Catalogue Raisonné.* Her photographs, which are represented in several museum collections, have been exhibited in museums and galleries around the United States. They have appeared internationally in *Geo, The Los Angeles Times, The New York Times,* and other publications. She teaches at The City University of New York.

The text of this book was set in a film version of Century Schoolbook, one of several variations of Century Roman. The original face was cut by Linn Boyd Benton (1844–1932) in 1895, in response to a request by Theodore Low DeVinne for an attractive, easy-to-read type face to fit the narrow columns of his *Century Magazine.*

The display type is Poor Richard, set for the second edition by Dan Solo of Solotype in Oakland, California.

Printed and bound by Friesens
Design by Dorothy Schmiderer